The Ancient
Alchemy
COLORING BOOK

The Ancient Alchemy
COLORING BOOK

··········

Celtic Knots, Mandalas, and Sacred Symbols

··········

CHER KAUFMANN

THE COUNTRYMAN PRESS · WOODSTOCK · VT.

For information about permission to reproduce selections from
this book, write to Permissions, The Countryman Press,
500 Fifth Avenue, New York, NY 10110

For information about special discounts for bulk purchases,
please contact W. W. Norton Special Sales at
specialsales@wwnorton.com or 800-233-4830

The Countryman Press
www.countrymanpress.com

A division of W. W. Norton & Company, Inc.
500 Fifth Avenue, New York, NY 10110
www.wwnorton.com

978-1-58157-363-3 (pbk.)

10 9 8 7 6 5 4 3 2 1

Contributors:

Barbara Sadler, Dala Horse
Margaret Correa, Rose
Solina Marquis, Turkish mandala
Sue Hegel, Mandala 5
Serrah Riege & Cher Kaufmann, Dragon

"Symbols are the imaginative signposts of life."

—MARGOT ASQUITH

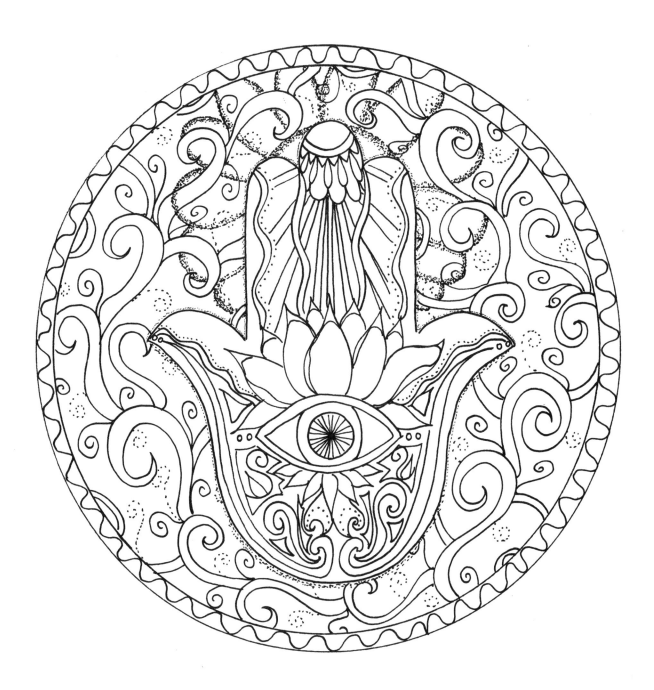

Artists, historians, and alchemists have always used science, observation, and symbols to help us understand and explain the world. Symbols can mark our way as we learn and grow. We can use them to tell stories, both fact and fiction. Something as simple as a circle can stimulate knowledge and emotion, and as you layer another circle or a line or a square on the original design, so too does the meaning become more complex and multilayered.

Symbols derive their meaning from the culture that puts significance into them. These symbols can be used as language, prophecy, warnings, decoration, protection, declarations, adornment, reflections, and for enjoyment. There are some cultures whose symbols have survived for thousands of years, and, for many, they still have importance.

Mandala (correctly pronounced mahn-dah-la) is one such long-surviving symbol that has even crossed cultures. A mandala is often described as a "circle" but a more accurate meaning would encompass the deeper essence of all relationships. Mandalas represent harmony and wholeness within the universe. Hindus and Buddhists use mandalas in context with sharing the significance of spiritual connections from higher realms; they are reminders and windows to deities in meditative moments and in everyday living. Other cultures and religions have used the geometric design of mandalas by including a significant symbol of a religion or deity in the center of a circle, and sometimes by placing other symbols of minor deities or specific imagery in and around the picture to enhance the importance of the image.

The history of mandalas is rich in symbols and in the Tibetan Buddhist tradition. To create a mandala takes training. The famous and intricately beautiful sand mandalas are created over a period of many days (depending on how large one is, it can take from four to thirty days) and are then deconstructed in a ceremony honoring the cycle of life and the flux of change. This ritual serves as a lesson on the impermanence of life and how nothing lasts forever, no matter how long it takes to create or how beautiful it appears.

Symbols used in mandalas often represent aspects of life. In Chinese and Japanese cultures, they use nature to represent the hidden strengths inherent within. The Chinese have three basic categories that are used in art: figures, landscape, and floral/bird imagery. While these three categories may seem simplistic, they often embody much more than what they seem. For instance, the strong smooth growth of bamboo can mean good fortune, auspiciousness, respect, strength, and adaptability. The peacock represented in art from Hindu, Buddhist, Greek, Christian, and other cultures has a wide variety of significance. The peacock can symbolize beauty, peace, nirvana, compassion, immortality, and benevolence.

The Celts used intricate patterns, interweaving and interlocking continuous lines to create what we know as Celtic knots. Their mesmerizing mazes have been mistakenly thought of as aesthetic only in nature—not practical—but these particular knots were much more than they appeared. They became a way of drawing humans and animals during a period in time when the religious rulers forbade such an act. The knots also represented the continuous cycle of life, much like the Buddhist mandala.

Metalwork is one of our best records of the times and symbols of historical past. Through

efforts of sovereignty or warfare, symbols on swords, shields, knives, armor, and jewelry (for adoration or practical use) have survived to show us how they wanted to be seen and remembered. Coins are also solid symbol keepers and, while they often get rubbed to bareness through time and use, they are valuable points of interest for the epochs. A silver coin depicting a sea turtle aegis from the 5th century was used as inspiration for one of the images in *The Ancient Alchemy Coloring Book*. This coin shared information on how turtles were symbolized with a single layer of plates down the center of their shells. Turtles have been regarded as dual symbols of the harmony of heaven (top shell) and earth (under shell)—as well as longevity.

Creatures of the planet—actual, mythical, or extinct—have been studied, drawn, painted, sculpted, idolized, and honored for as long as humans have been able to record their experiences. Plants and animals are used to represent elements of nature, personalities, and power. They can also represent calmness and peace. Mythical creatures such as dragons are common in cultures and can be found in various shapes, sizes, and forms. Dragons as ancient symbols are more serpent-like in design, and are considered to be very powerful.

In New Age constructions, the artwork often shows symbols from an ancient past. The Flower of Life is representative of both sacred geometry, popular with spiritually minded persons as a call to reconnect to all of Nature, and ancient geometry. The Flower of Life symbol dates as far back as The Temple of Osiris in Abydos, Egypt, and is also on the ball under the giant paw of the famous Fu Dog, a Temple Guardian (Lion) in Beijing, China, which dates back to the Ming Dynasty. Lotus flowers, the Tree of Life, sacred geometry, and mathematical equations, such as the Fibonacci Spiral, have existed for much longer than contemporary fascination. The

Fibonacci Spiral can be found in all living things, from flora and fauna to humans to the largest displays of the galaxy. From the smallest to the largest places of being, therein lies a symbol.

The hand-drawn images in the following pages are inspired from actual metal works, textiles, drawings, and historical records left behind from cultures past. They are intertwined with patterns from our world for your enjoyment. Now it's up to you to bring them to life with color and imagination.

The Ancient Alchemy Symbols Guide

ANANSE NTONTAN, also known as **ANANSI** or **THE SPIDER,** is a flower-like symbol of the spider's web, holding great wisdom and creativity, expressing the complexity in life. The legend of Anansi the spider, the African spider God, is described as the "owner of all the Supreme Being's stories." Spiders in Native American lore share a similar representation, connecting communication, language, creation, and mischievous behavior.

BAMBOO has been used in art, in gardens, and in the home as a symbol of good fortune and auspiciousness. Bamboo's ability to grow strong and tall, straight or curled around obstacles, all while moving gently with the wind, signifies strength, adaptability, and respect, especially in Asian cultures.

BEAR signifies courage, power, protection, and resourcefulness. Bear can remind us of the need for solitude—hibernation in their case—as a healing quality, creating harmony from everyday activities and exertion. Bear does, however, also exhibit unpredictability, so they can also represent being aware of unforeseen changes.

BIRD has many depictions from the Sun and the Sky, peace, freedom, and the soul. Bird, in ancient cultures, also represents a messenger of the Gods. There is a special portrayal of **BIRDMAN** in several indigenous cultures as an all-seeing Supreme Being. Bird uses an inherent navigational system and can migrate with the seasons, expressing the ability to trust the wisdom of movement in life.

BIRDMAN: see Bird.

BUTTERFLY is a symbol of beauty, a special kind of beauty that only comes from powerful transformations. Butterfly characterizes metamorphosis, transition and growth of the soul. Butterfly has also been known to take the wishes of wish-makers up to the heavens.

CAT, with so much independence and mystery, represents magical connections with a unique style of cleverness and curiosity. Cat was worshipped in Egypt but has always had a particular supernatural connotation, probably due to their heightened sensitivities to sound, movement, smell, and changes in environment.

CELTIC KNOTS are intricate overlapping knot patterns used to represent daily and spiritual meanings. Certain knots have significant interpretations, from relationships (Mother/daughter, or love knot) to plants and animals (Tree of Life, Bird, Bear) to spiritual accounts (Triple Horn of Odin). Celtic knots were

born out of the need to express language through symbols when written words did not exist, at a time when written expressions (of spirituality, especially) were forbidden. Overlapping patterns have been recorded as early as the 3rd and 4th centuries within the Roman Empire, but the unique symbolism connected to the importance of nature and relationships comes through specifically in Celtic knot work and design.

CHAVÍN GOD is an unnamed God image from the pre-Incan Peruvian peoples from Chavín de Huantar. Common images show pupils looking upward and large teeth embedded in gold or stone. While there were many Gods in the Chavín culture, all the portrayals shared characteristics. The Chavín were masters at technical craftsmanship, using gold to depict tropical animals, felines, birds, and images from their ritual hallucinations. Perhaps the Chavín God is a result of such rituals.

CHERRY BLOSSOMS, known as *Sakura* in Japan, have special meaning in both China and Japan. In Asian cultures, everyday items can express much more than their appearances. Cherry Blossoms are delicate flowers that decorate the tree with full canopies, which then fall like a gentle rain at the peak of their blooms. Because of this short life cycle and elegant appearance, Cherry Blossoms are often associated with the life and death cycles, as a reminder that nothing lasts forever. Hope and Love are most often correlated with the blooms and the tree has always been considered sacred for the grace within its inherent nature. Cherry blossoms represent all aspects of life and death: beauty, love, hope, friendship, impermanence, reproduction, celebration, and respectful consolation.

CLOUDS, with their wispy appearance and location so close to the "heavens," symbolize a way to ascend to the sky to become enlightened (Buddhism). Their ability to change shape makes their presence mysterious. That Clouds bring rain or shade also adds to their appeal in ancient symbolism.

DALECARLIAN "DALA" HORSES (HORSES) began as small, hand-carved, wooden horses and have slowly evolved into the symbol of Sweden. Horses in general have been painted, carved, and etched as far back as cave drawings. Strength, stability, trust, honor, and courage have been synonymous with the horse as a warrior, a community creature, and a hard-working animal throughout history.

DRAGON is most often seen in (but is not exclusive to) Asian cultures as a very powerful protector, representing wealth and abundance, success and prosperity. When Dragon is paired with Phoenix, it is a particularly powerful creation of auspiciousness in relationships. Dragon also endows self-confidence and demands respect, and has been said to have enormous wisdom. Often detailed in gold or precious metals, this decorum represents the fortune of the good luck Dragon symbol.

ELEPHANT, known for their incredible mental capabilities and memories, also represents wisdom and strength due to their enormous size. This powerful creature symbolizes community and loyalty. Elephant is especially revered in Indian and Asian countries, and is used in festivals, often decorated with colors and spiritual symbols.

GECKO/LIZARD, known for their agility, intelligence, and ability to regenerate their own tails, are viewed in many cultures as symbols of good fortune with a distinct mysticism. Gecko has a shorter, broader head and rounded sticky toes to climb, and Lizard tends to utilize their claws and live on the ground. Both are well-adapted to living in hot, dry, and tropical areas.

HAKUNA MATATA are two Swahili words with a single unique symbol. The words literally mean "there are none" and "difficulties," and together translate to "there are no difficulties," because in Swahili, there are different ways of expressing "no." Its deeper meaning, however, is to trust the cycle of life, that life will go on… It's not exactly like the Disney song, but close!

HAMSA is used in several cultures, but it is most often used as a symbol for protection and "forces of good": faith, abundance, and positivity. Also known as "The Hand of Fatima" in Islam, it is most commonly portrayed with the thumb and pinky fingers being the same size and can be used facing upward or downward.

HUMMINGBIRD possesses her swiftness and is seen as the embodiment of love, lightness, and joy. Hummingbird's ability to make quick, territorial movements shows adaptive qualities and fearlessness. She is intriguing and mystical for her brilliant colors and reflective feathers, not to mention being the smallest bird in the world.

HUNAB-KU, Mayan for "there is one"-"God," is a symbol associated with a Universal High Supreme Maya God—but history shows that this symbol, and its meaning, did not have

any direct association with the Maya. In fact, the closest evidence to the origin of this mysterious symbol points to a rectangular design in the Aztec codices used as a ritual cloak. A further change in understanding ensued when an author in the 16th century made reference to the symbol, assuming significance to the Maya. There is further evidence that this particular symbol may have appeared jumping to the Maya from the Aztecs after Europeans invaded South America and introduced a Christian deity. Regardless of the history, the *Hunab-ku* is a beautifully harmonized design likened to the indigenous Yin Yang.

I CHING's hexagram, also known as the **UNIVERSAL COMPASS,** consists of eight patterns that represent elements of nature— the tendencies and inherent qualities therein. The full *I Ching* is a set of 64 patterns that repeat from the original Universal Compass: eight patterns to distinguish specific and exacting information about situations, persons, places, and things. Used for thousands of years and one of the oldest forms of divination, the *I Ching* and the Universal Compass are complex and intricate methods of gathering information on the direction and purpose of life.

KOI FISH are descendants of the common brown carp. Chinese farmers originally raised carps in rice paddies. After being exported to Japan from China, the Japanese began to notice different colorations in certain fish, breeding the mutations to create the colorful Koi. These Koi were raised as pets in local ponds and admired by emperors and villagers alike. In Japan, Koi are known as *nishikigoi* (living jewels) and have been revered as symbols of beauty, good fortune, success, prosperity, longevity, courage, ambition, and perseverance.

KOKOPELLI, a popular fertility God (Hopi/ Anasazi) from the southwestern United States, depicts a hunchbacked figure dancing with a flute. The rounded area on the Kokopelli's back has been speculated to be a bag of seeds as he went from village to village bringing rain and changing winter to spring. Kokopelli not only represents new life in the change of seasons, bearing seeds for a new harvest, but he is also used to represent fertility, bringing new babies to families after the spring festivals. Hence the song from the flute and dance in his image.

The **LOTUS FLOWER** is especially abundant in Egyptian, Japanese, Chinese, and Indian spiritual cultures. Buddhists notably use

the Lotus to represent enlightenment, as the famed splendor of Lotus comes from the depths of a pond's muddy roots. Egyptians saw the flower as a symbol for the Sun, since it would close up when the sun went down and open again when the sun rose. Lotus is the only plant to flower and fruit at the same time, and only comes in pink or white. Lotus is uniquely inclined to symbolize spirituality as well as beauty, purity, spiritual awakening, enlightenment, and divinity.

MANDALAS, most often translated as "circles," are patterns coming from a center, often depicted in circular or square images and representing the relationships of a central individual and a universal source of symbolic imagery. Tibetan Buddhist mandalas have "four gates" which symbolize the four directions: north, south, east, and west. Mandalas historically carry symbolic significance in each icon, direction, petal, and color. Each characterizes a way to overcome and call upon a life of happiness, by employing the gifts of the deities they represent. In modern times, mandalas are used for meditative purposes and relaxation methods, both in practice and aesthetics.

The **MAYAN CALENDAR**, with its intricately detailed three-layered stone logbook (solar, divine, and astronomical, all used simultaneously) made quite a stir with its translation of dates that ended in 2012. People from around the world wondered if this amazing cyclical map of ages represented the end of time. The Mayan Calendar has specific representations of everyday spirituality and long-term calculations that run in a loop.

The **MOCHE** were an artistic group of people who lived in South America, associated with areas of the Inca. The Moche used decorative pieces of jewelry, gold sheets, textiles, and pottery to express their beliefs and way of life, along with their connection to nature. Earspools, discs worn in the earlobes, were common for the Moche to wear—the larger the earspool, the higher the ranking of the individual. The Moche were particularly fond of decorating pottery in alternating patterns of color, using stone and precious metals.

NEA ONNIM NO SUA A OHU, the West African symbol, means "He who does not know can know from learning." With its many connecting lines representing a lifelong pursuit of knowledge from a bounty of avenues and sources, it's a great reminder to all of us to learn something new every day.

NKYIN KYIN shows, with its zig-zag pattern, that learning from past mistakes and adapting

to new circumstances grants versatility and initiative when shifting into the changing roles of life. Each life will have many roles: for instance, a girl can be a sister, woman, wife, mother, and grandmother, and will require flexibility, like the zig-zag, to ground and root herself into a well-rounded, experienced person. *Nkyin Kyin* is a West African symbol, but turned sideways, it almost looks like the English word "we," or the word "love," both of which also require flexibility to function in a healthy fashion. Much like life, love needs *nkyin kyin*.

NYAME DUA, the West African Tree of God symbol, visually resembles a four-leaf clover made of four hearts, but it is meant to represent the place where heaven and earth come together and humans come to know themselves within the harmony of nature. This is a place where the wisdom of all that is comes together and imparts insights, an opening for humans to be in harmony. *Nyame dua* is where rituals are held, and this symbol is also placed in front of the house or building. It is made from a tree that is cut from where three branches extend. It symbolizes God's protection and presence.

OUROBOROS, the infamous snake/serpent/ dragon that eats its own tail, symbolizes the eternal life cycle of renewal and purification. The dual nature of all existence and the lack of conflict of this duality—where opposites unite—is Ouroboros. The snake must eat to survive, but to eat itself implies its own destruction. And yet, this is the only way to ensure survival. The larger implication of this symbol is the tenacity of life finding a way to continue without conflict, because all endings provide new beginnings.

OWL, with his big eyes and great night vision, has been associated with intuitive knowledge and deep wisdom. In different cultures, Owl has also been connected to the mystery of death due to his ability to navigate in the nocturnal unseen and the beyond.

PEACOCK has long been revered as a symbol of beauty. Originally native to India, Sri Lanka, Burma, and Java, with lesser-known species in the African rainforests, the peacock is now known around the world for its unique feather plumes that constitute 60 percent of its length. Wholeness, love, compassion, and nirvana, as well as benevolence and immortality, are associated with this colorful bird. The white peacock is not a specific species but, rather, has a genetic mutation called leucism, which creates a lack of pigmentation in color, and

so the white peacock shares the beauty of a single color.

POTTERY STAMP designs were unique to the prehistoric North American Native American cultures. Recognized for their uniquely carved paddles, pottery stamps were used in the Southern Appalachian Group specifically, as well as in Central and South America; rarely, however, were they noted anywhere else in the Americas. These paddles were tapped into wet clay in random patterns as well as used to cover an entire vessel, a technique still used by modern pottery makers today.

ROSE has a special meaning due to its vast varieties and magical aroma. It has been said that Rose can affect the mind and heart by means of cooling and calming them, and stimulating love, respect, and friendship. Different colors can send messages of purity and peace. Spiritually, Rose equals the immortal love of the feminine divine in many cultures and beliefs.

SUNFLOWER, with its bright color and large circumference, embodies the magnitude of the Sun. The flower's presence is parallel to happiness, longevity, vitality, and, of course, love. Sunflower's remarkable ability to create edible seeds in a specific, central

pattern, a commonly used example of the Fibonacci sequence, the spiral of which is photographed often to document nature's recurrence in life.

TRAVELER'S COMPASS, also known as *Vegvísir*, an Icelandic word for "Guide Post," is a circular set of eight symbols, representing the directions of north, south, east, west, northeast, northwest, southeast, and southwest. This guide served as a symbol of protection for the traveler to always find their way home. This symbol was associated with the Vikings as they traveled across oceans and evolved to meet the needs of all travelers on any journey.

The **TREE OF LIFE**, while depicted differently throughout many cultures, shares a similar meaning of the place in which life becomes life and death become death in a constant cycle; renewal and spiritual knowledge are exchanged. The Tree of Life represents constant change within a place of growth and stability. Deeply rooted in divine knowledge and in the inherent qualities of existence, the Tree of Life is life given while also honoring death in the process, connecting both worlds. In this way, the Tree of Life symbolizes all of Creation.

The **TRIPLE HORN OF ODIN**, seen as three interlocking horns, represents Odin, the Norse God father figure. It is connected to the story wherein Odin uses his wits to drink a magical brew (or mead) three nights in a row in order to obtain mystical powers. Horns were used in toasting ceremonies, historically, and the belief system has codes of courage, honor, truth, and discipline as part of their canons.

TURTLE/TORTOISE has divine and magical properties, as she is the Earth to many peoples. She is also the connection between heaven (upper shell) and earth (lower shell). Turtle and tortoise share the wisdom of perseverance and longevity. In modern translations, she also represents the ability to set good boundaries (shell). Wisdom of the heart and home are always with you, not connected to any particular building or location, no matter how far one travels. Turtle and tortoise have internal navigational systems that lead them in a particular direction (usually toward water or breeding grounds); they also know, however, when it is time to retreat (hibernation or withdrawal into their shell).

UNIVERSAL COMPASS: see *I Ching*.

YIN YANG is the symbol of black within white and white within black, where dark and light share perfect harmony. Yin and Yang are opposites that depend on each other without conflicts. Yin Yang is constant motion and never static, shifting and changing in order to be in synchronization with itself. The day becomes night and the night becomes day in an ever-revolving cycle of good will on the planet. Every creature, plant, human, and system creates unity in an ever-coherent yin yang equilibrium, or else the imbalance becomes undeniable. Yin Yang is wholeness.

ZUNI SUNFACE, the Father Sun to the Zuni tribe, is responsible for the abundance of life, and growth in the garden and on the planet. Sunface shares continuity and stability by making life possible. Positive energy, hope, happiness, peace, and joy are all associated with the Sunface. The Zuni would often place this image on jewelry, typically made with turquoise, mother-of-pearl, red coral, and jet (fossilized wood). Each color represents a facet of the protection, intuition, happiness, and stability of the Zuni Sunface.

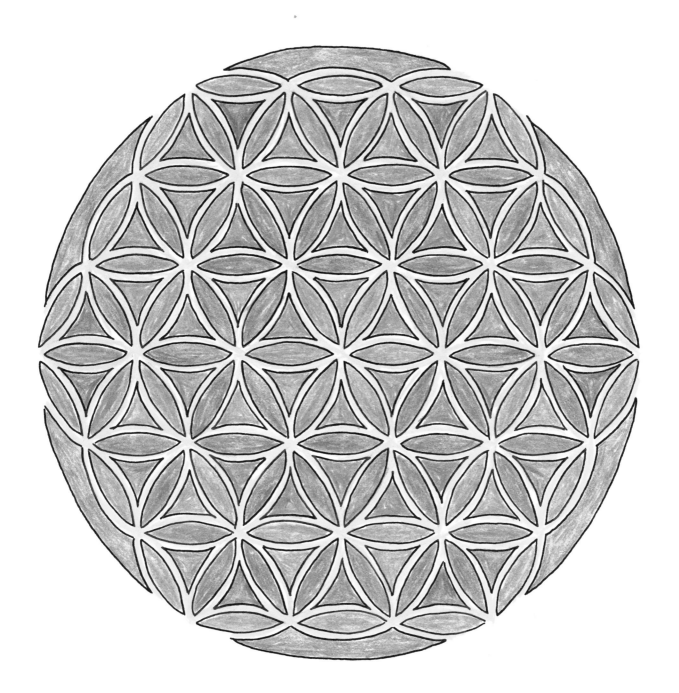

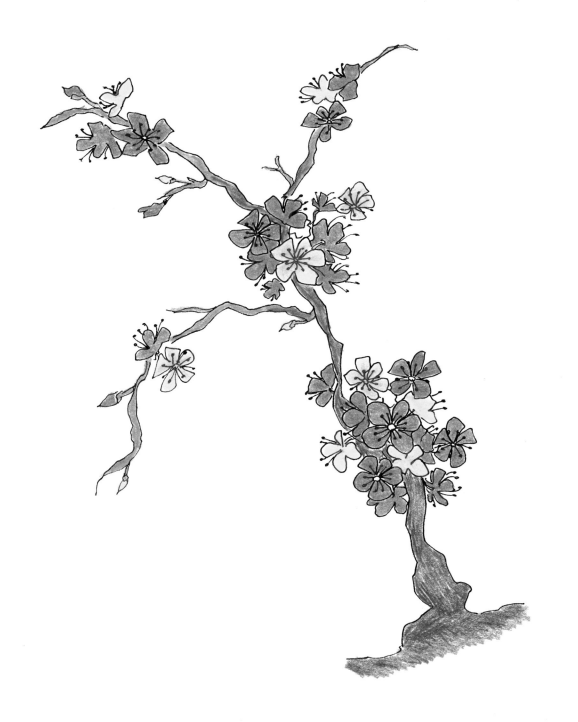

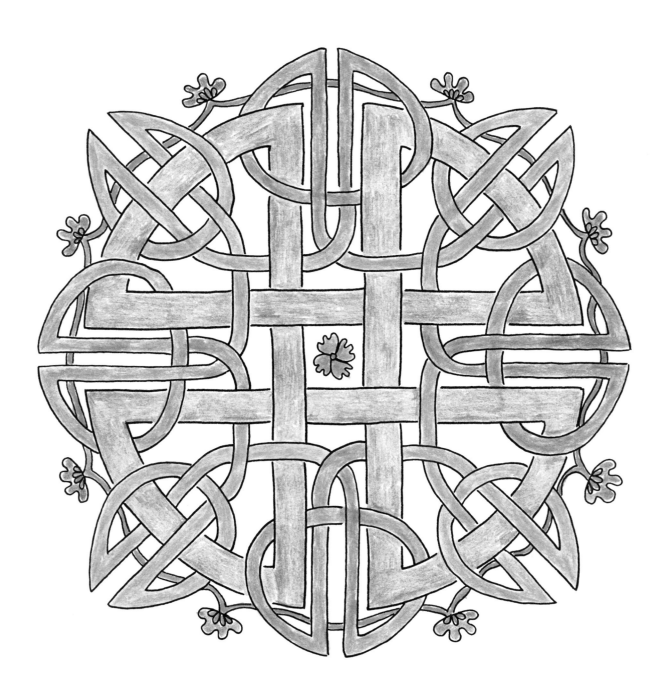

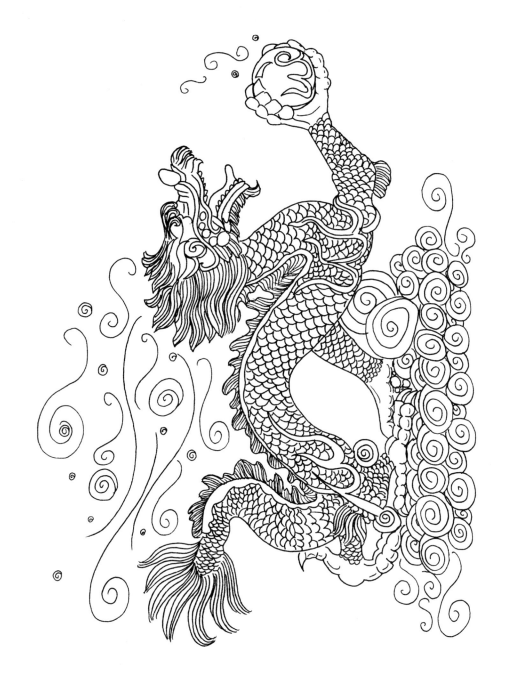

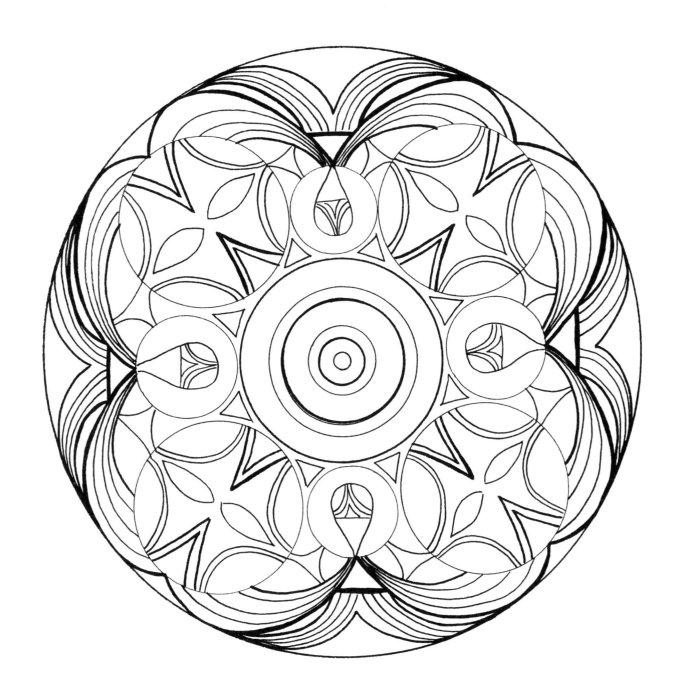

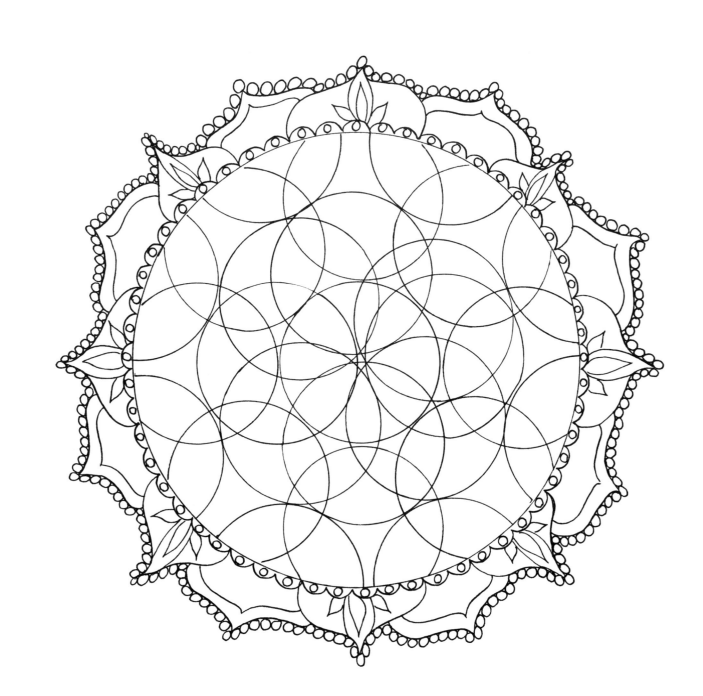

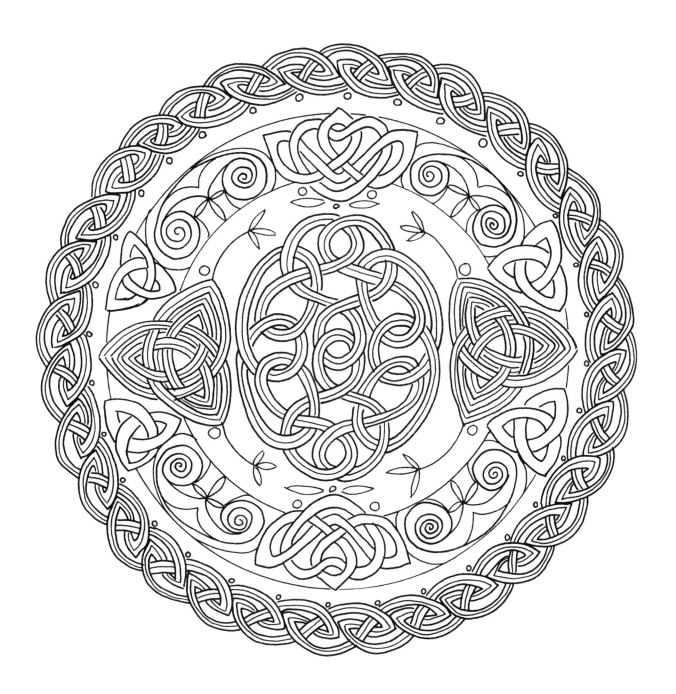

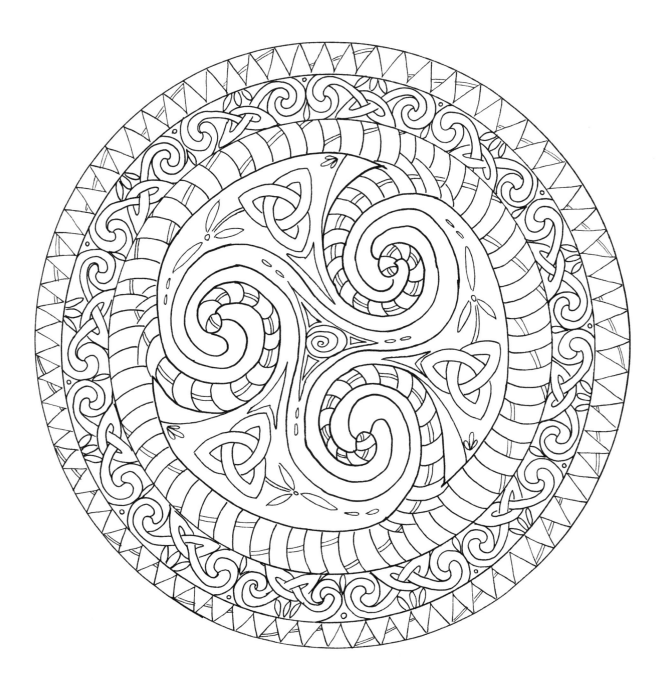

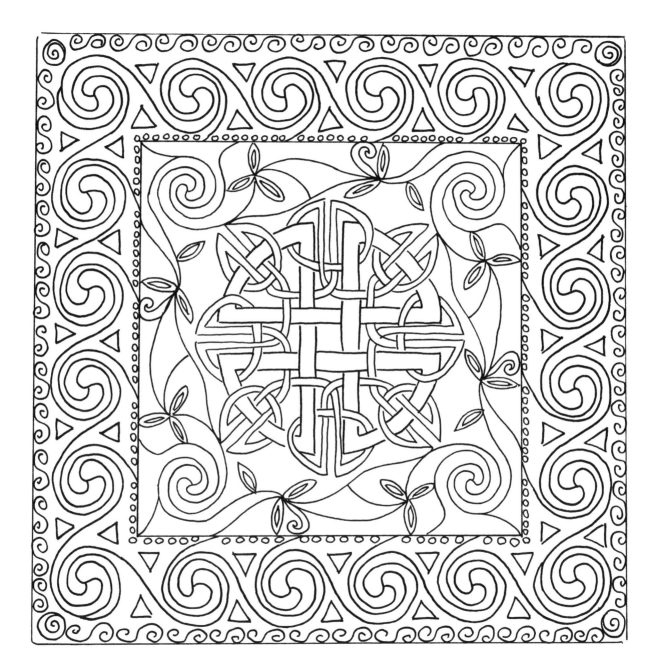

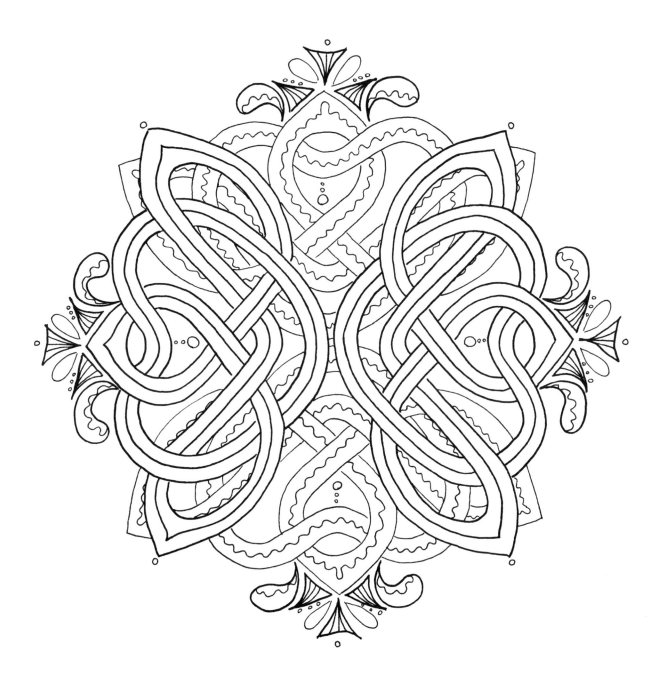

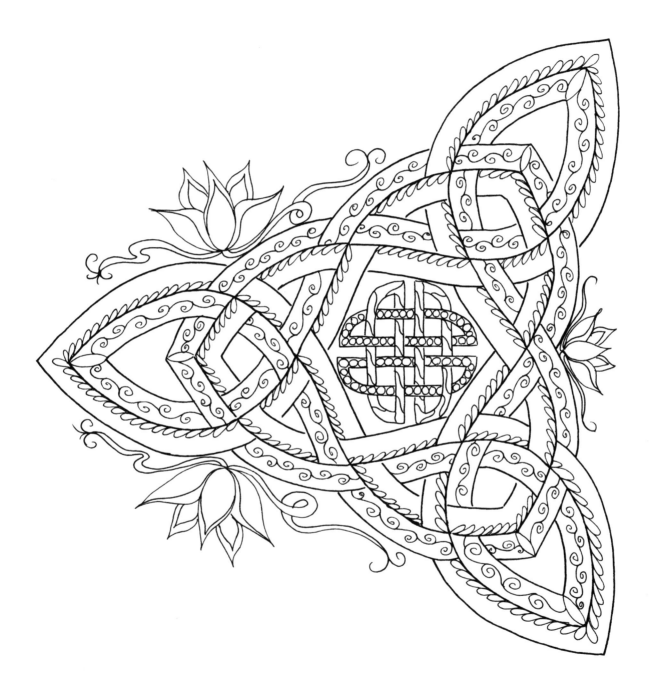

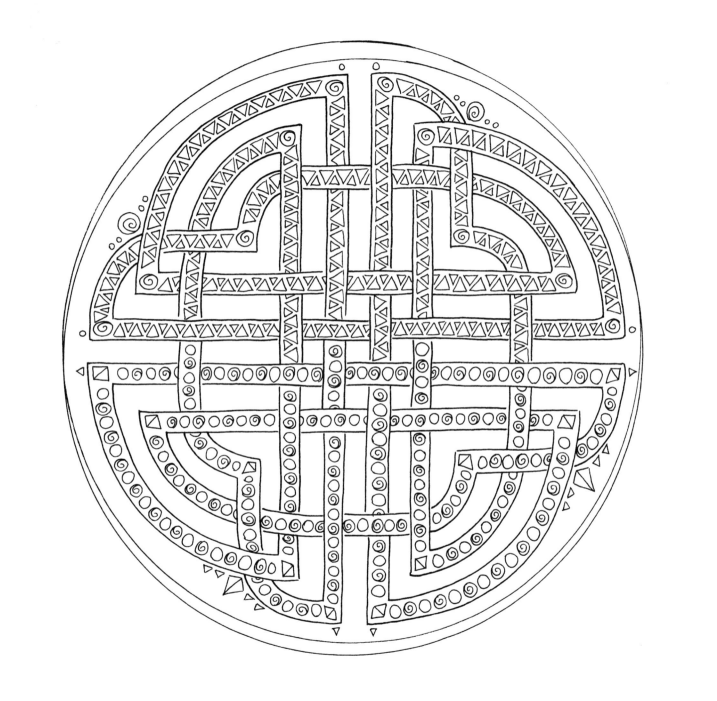

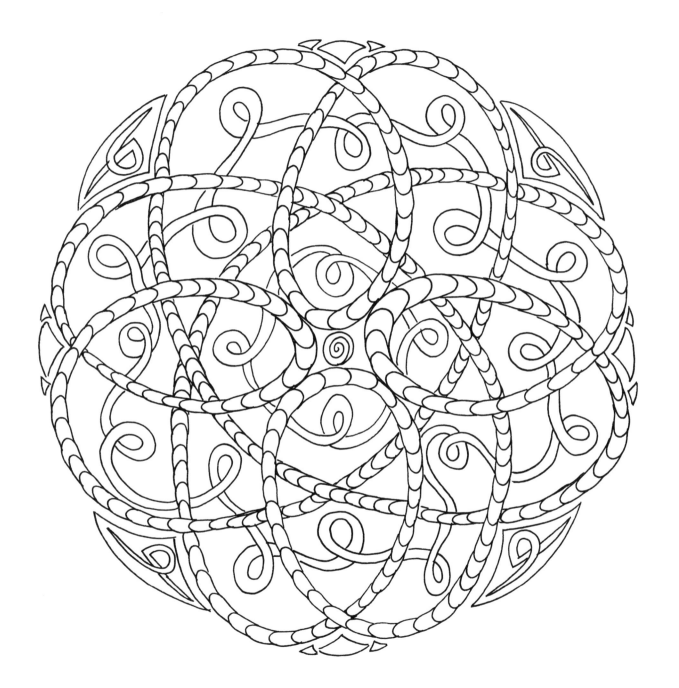

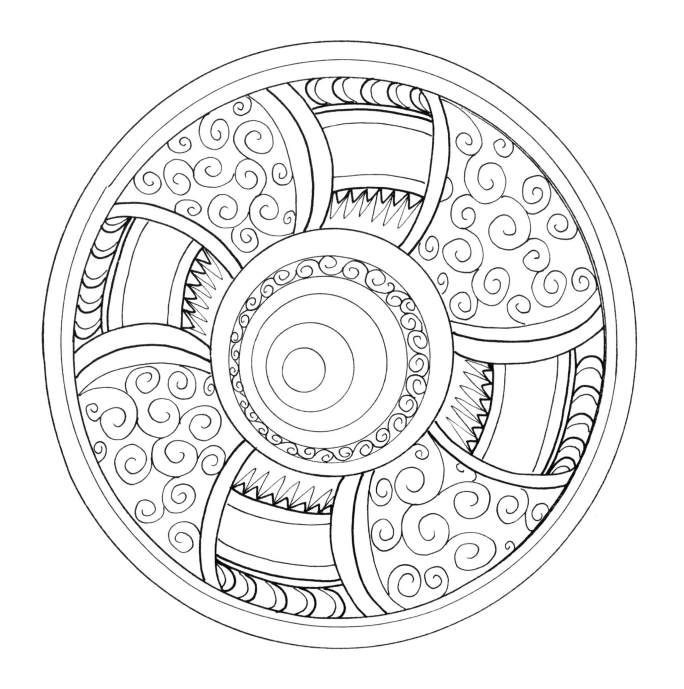

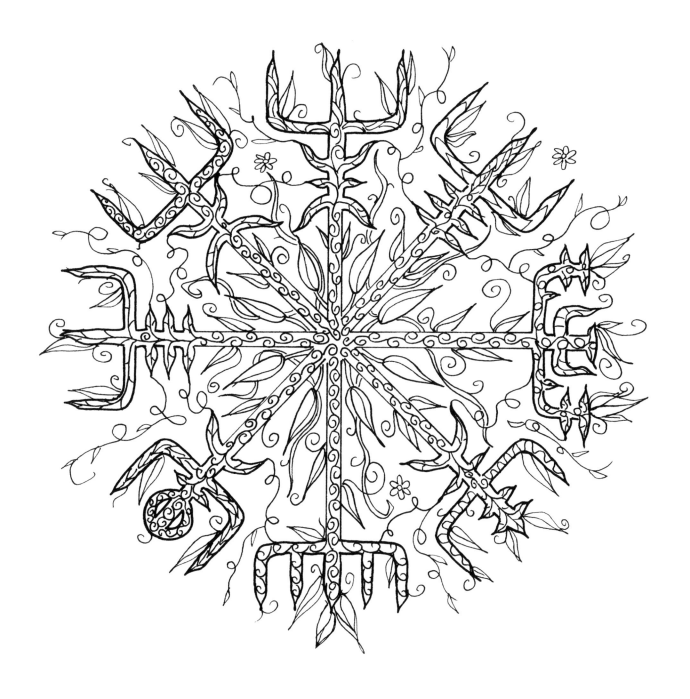

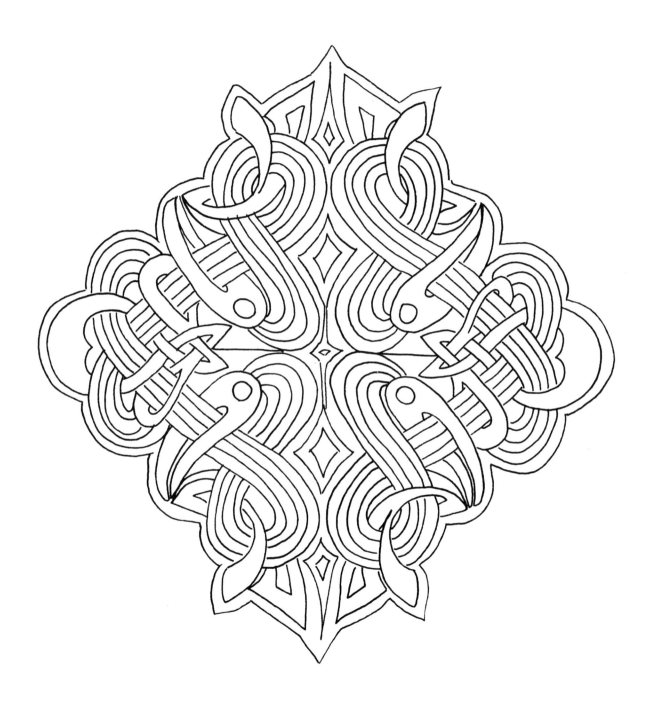

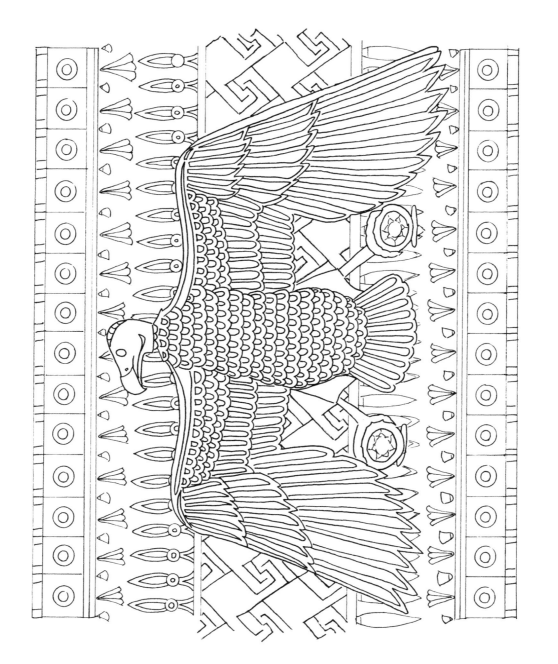

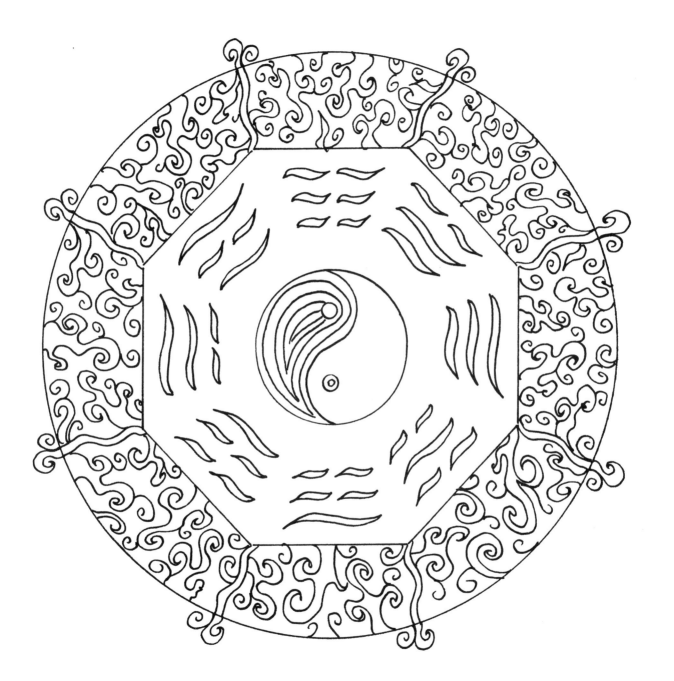

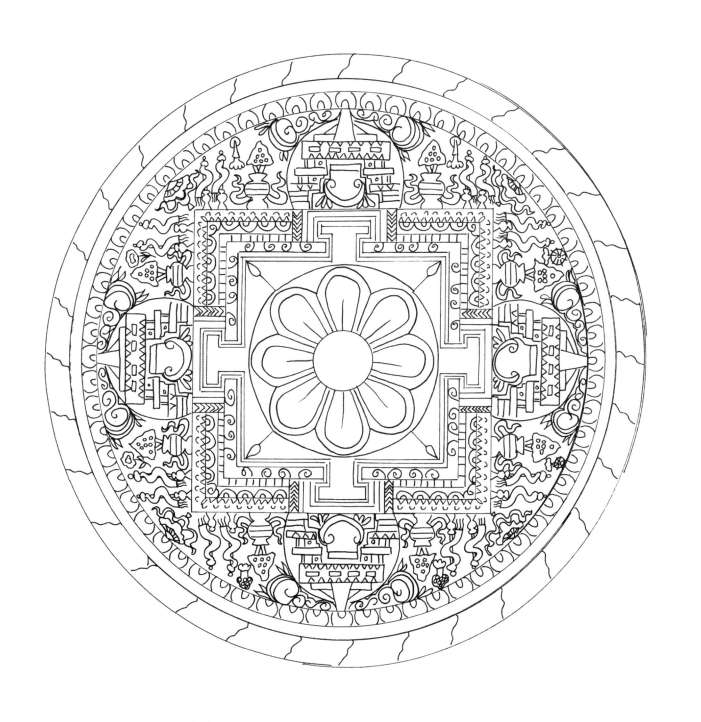

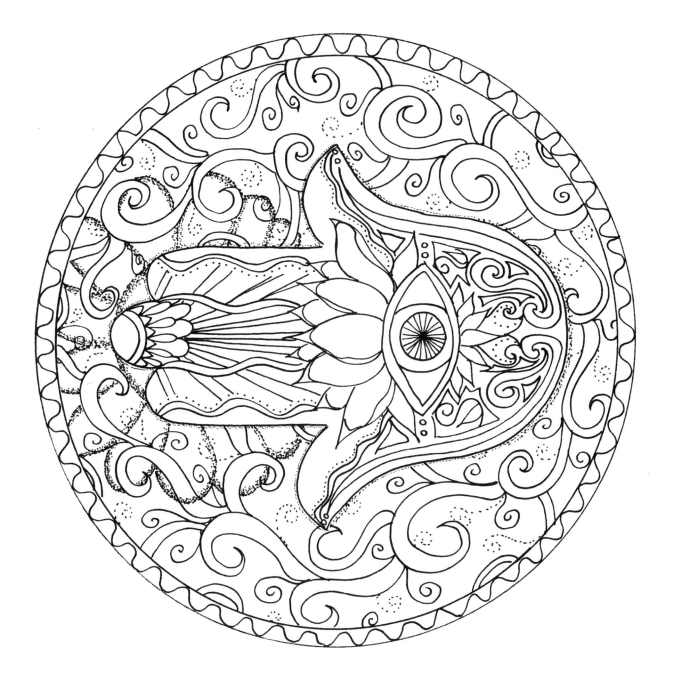

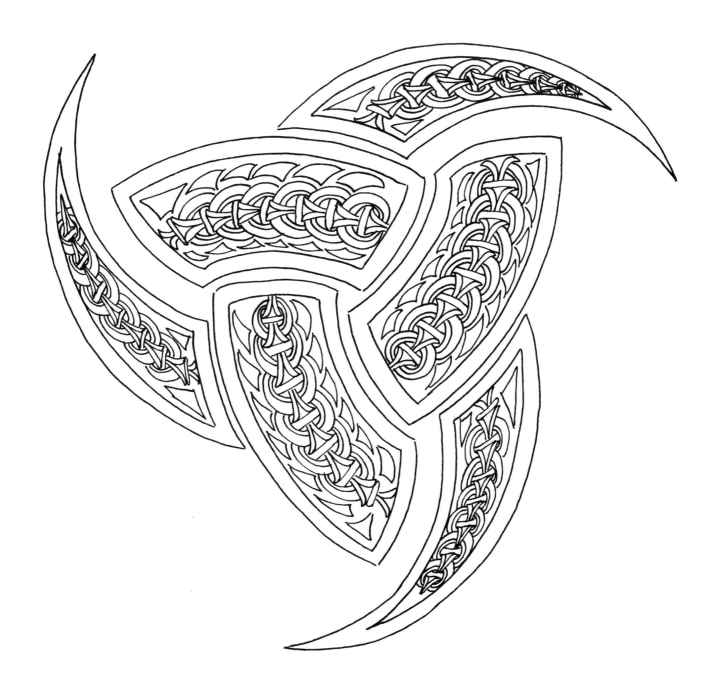

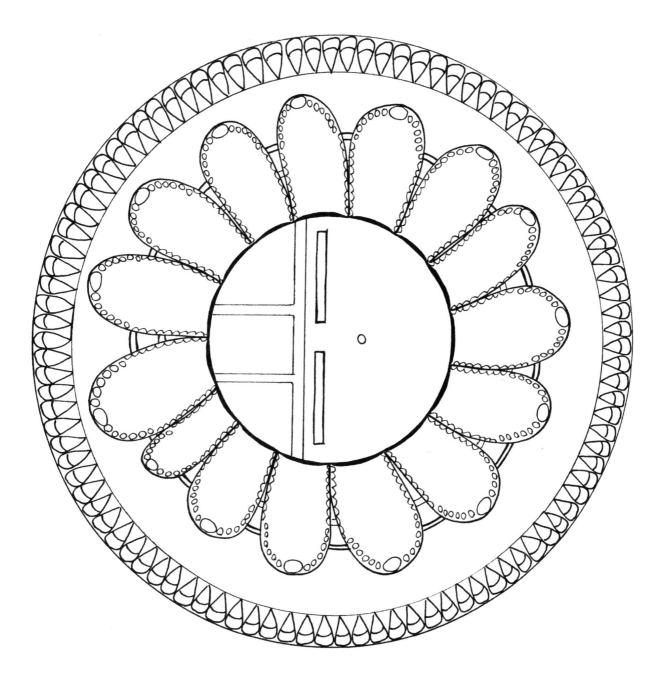

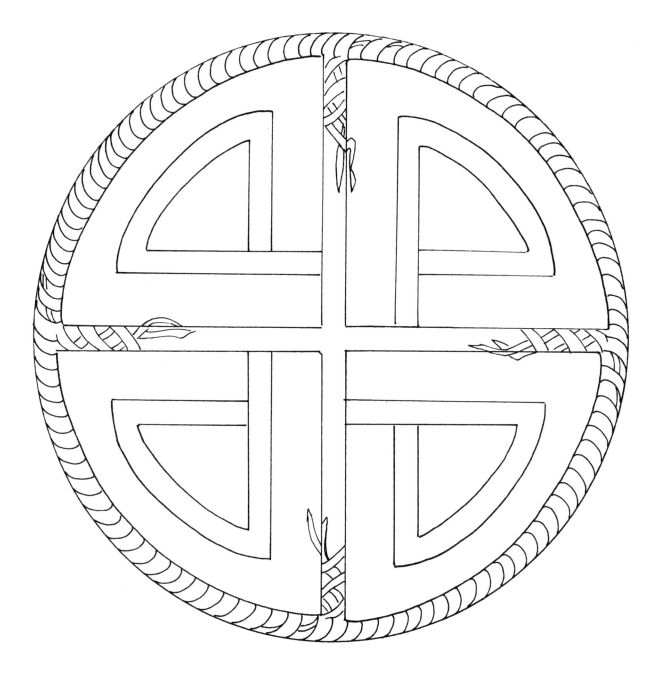

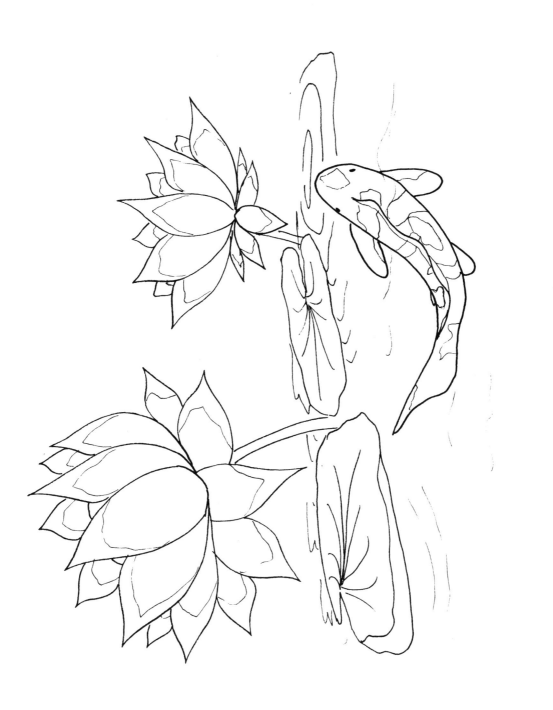

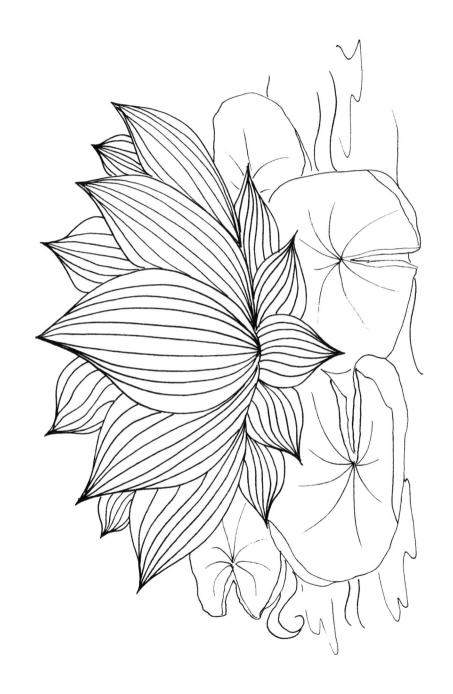

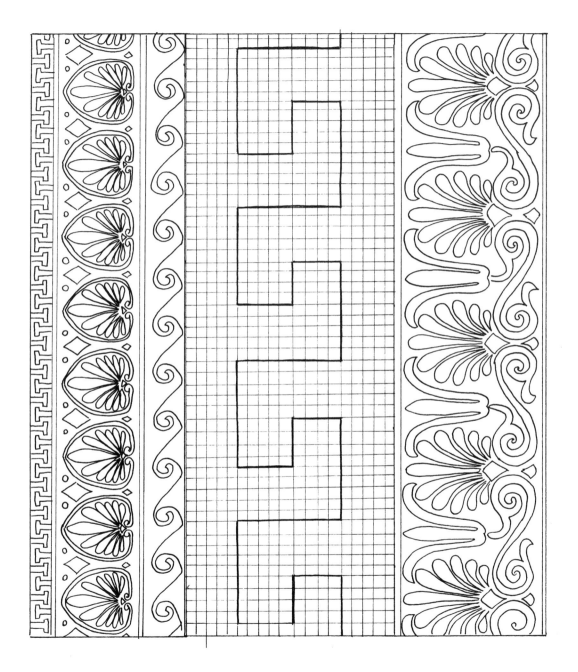

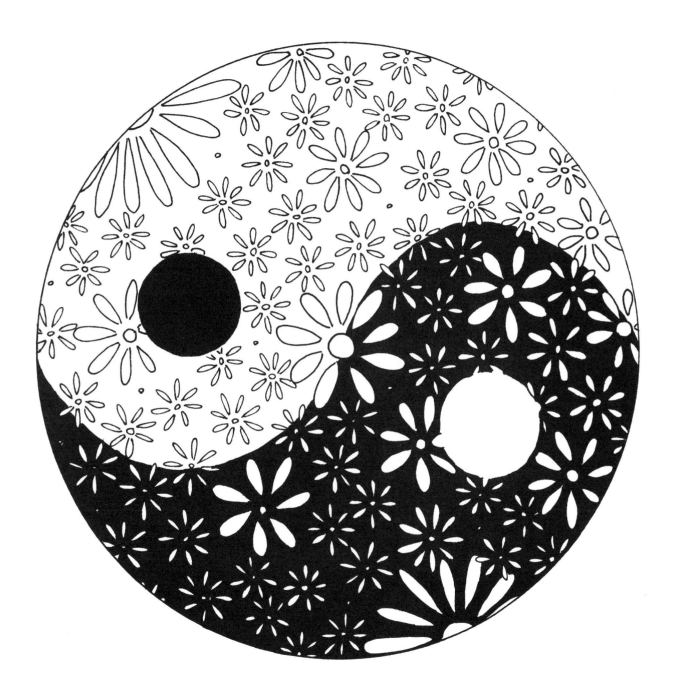

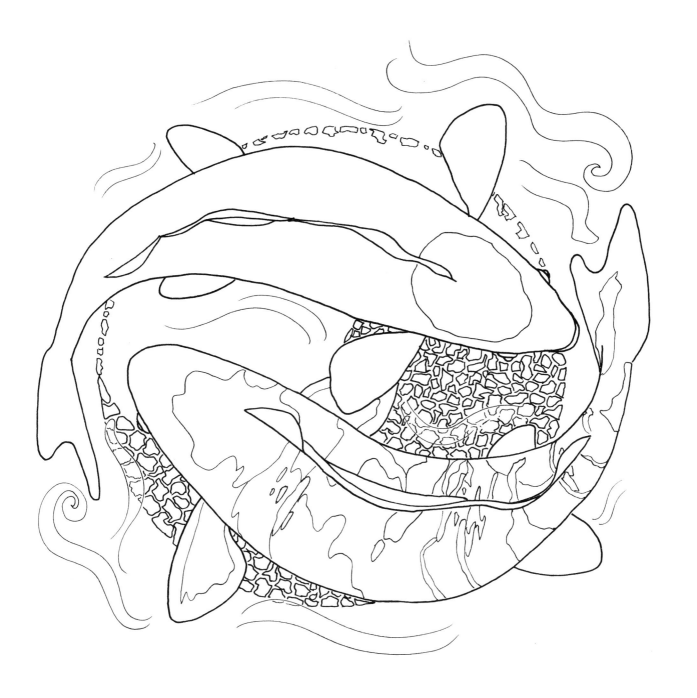

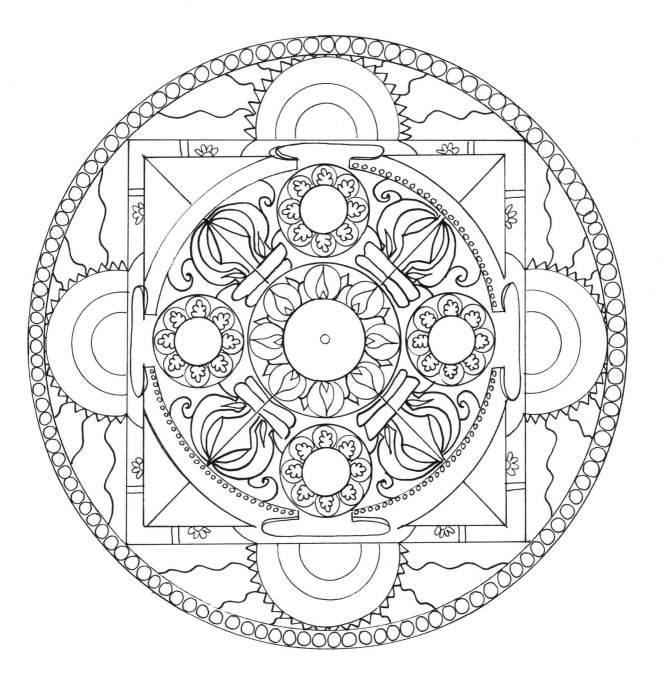

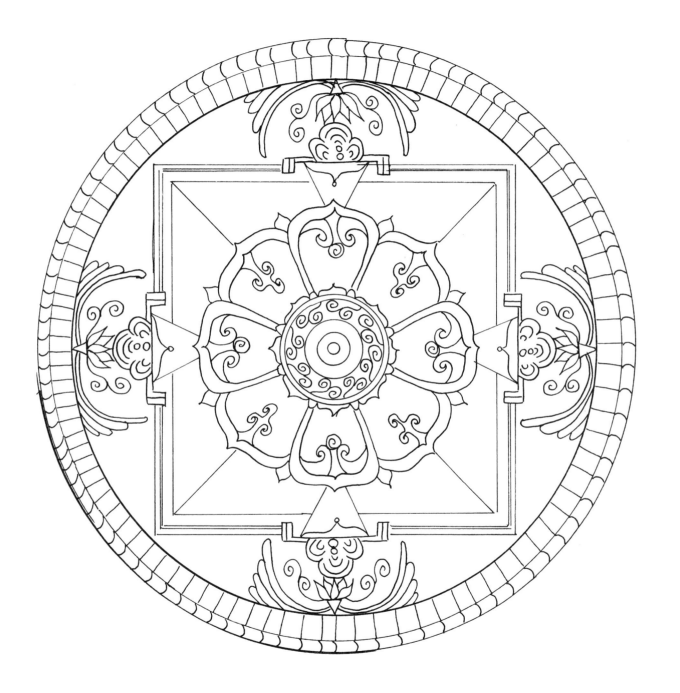

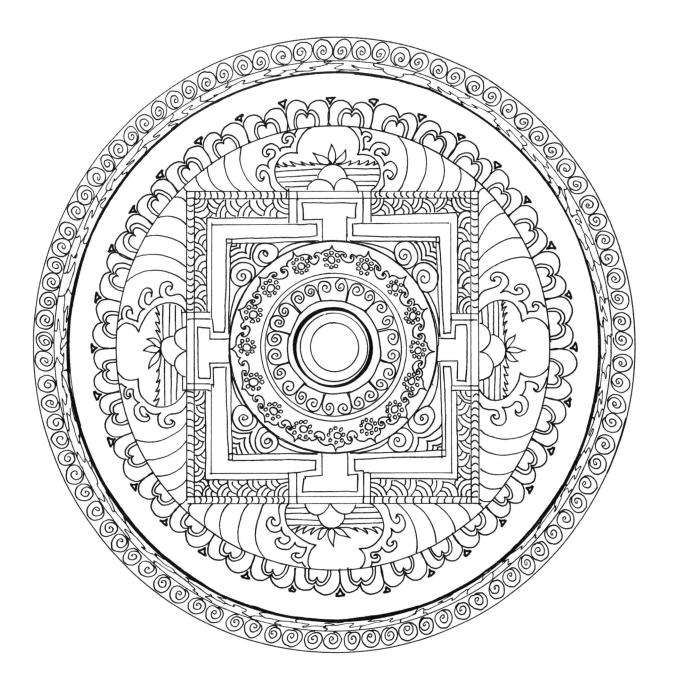

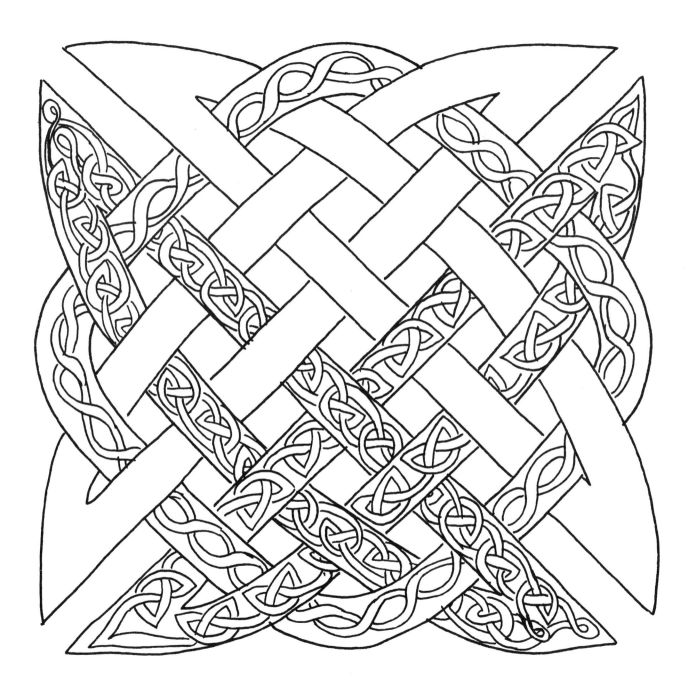

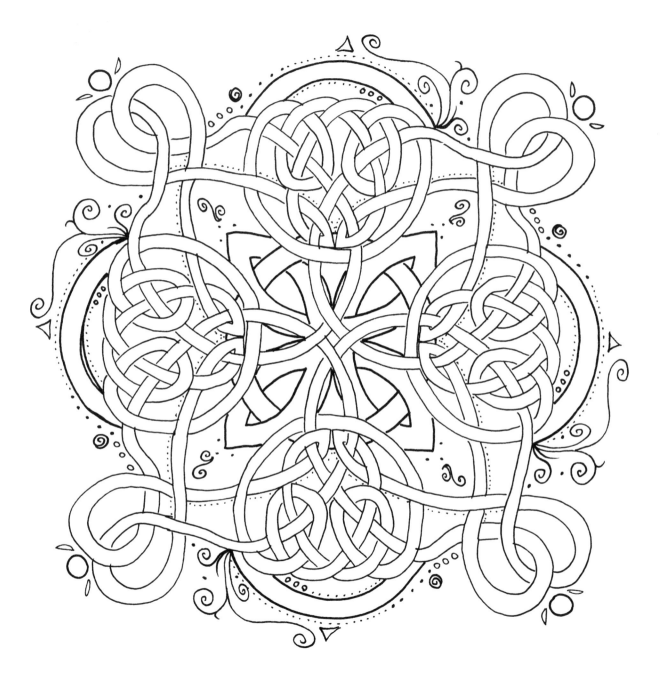

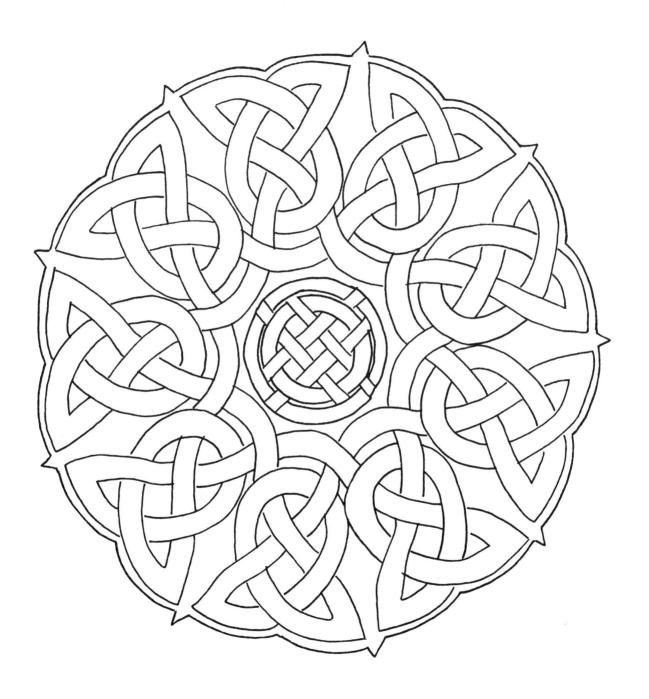

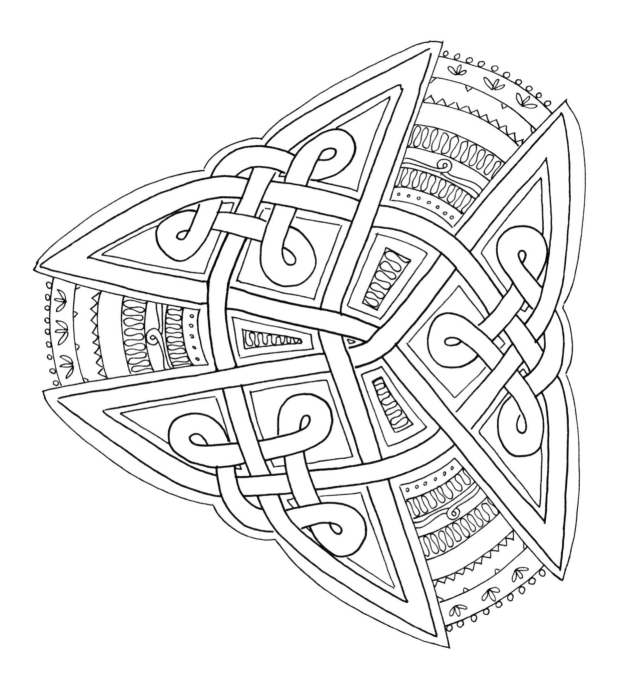

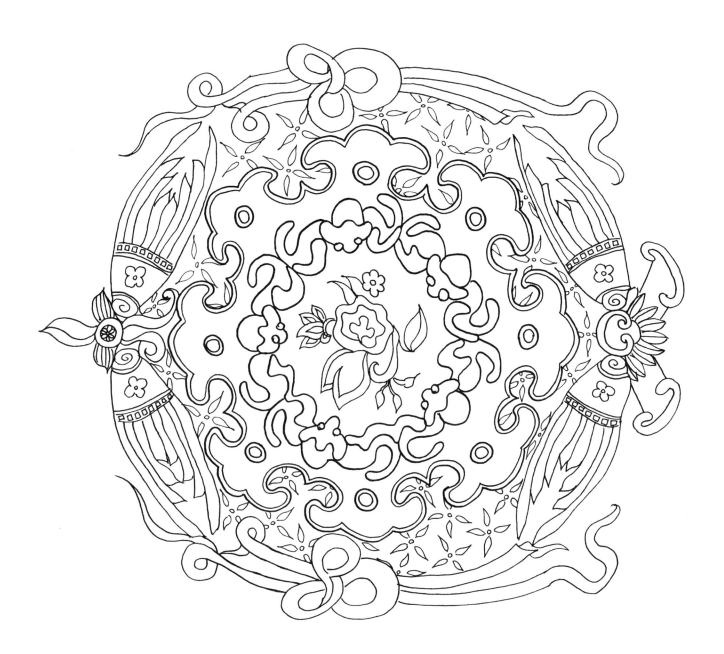

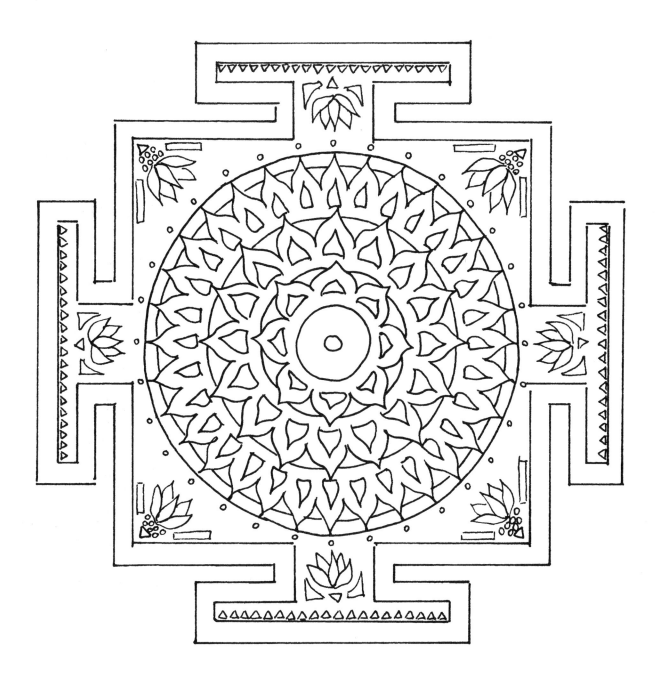

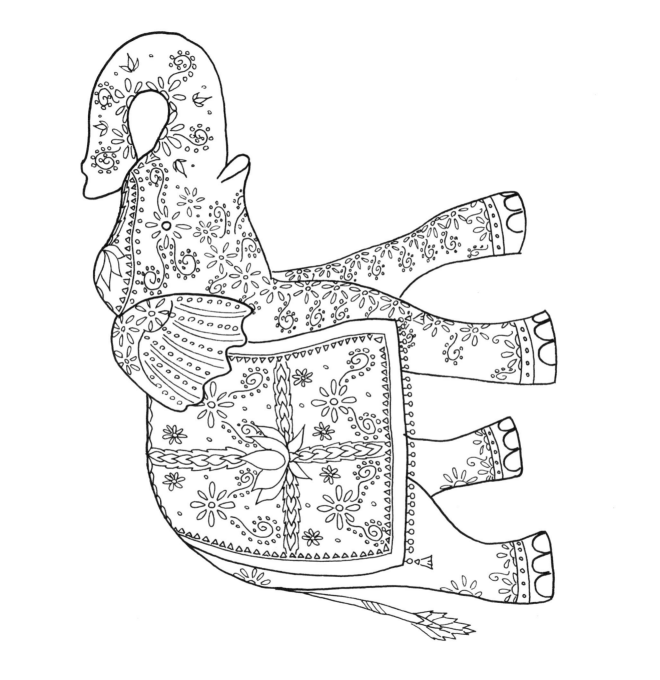

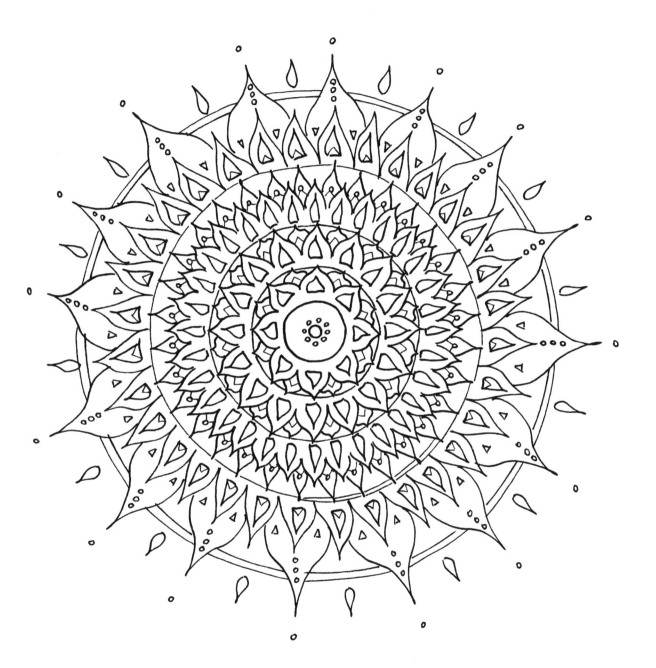

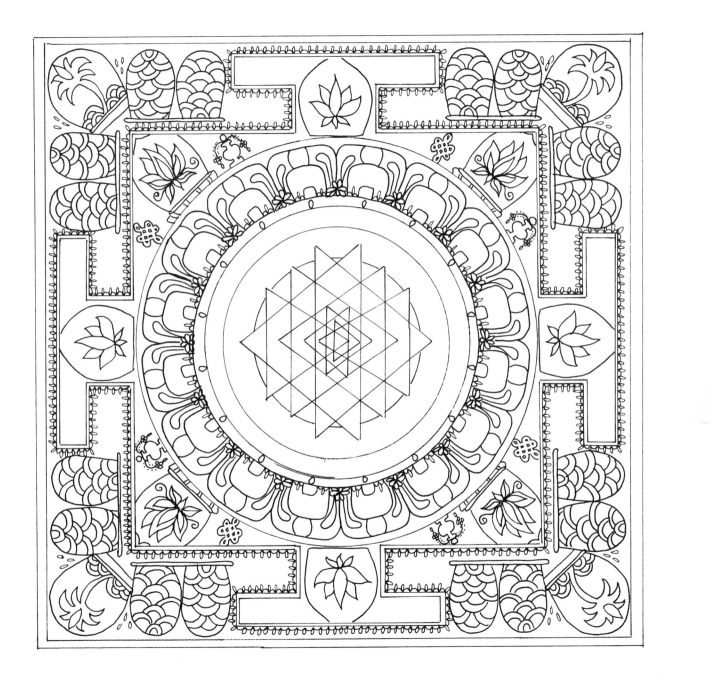

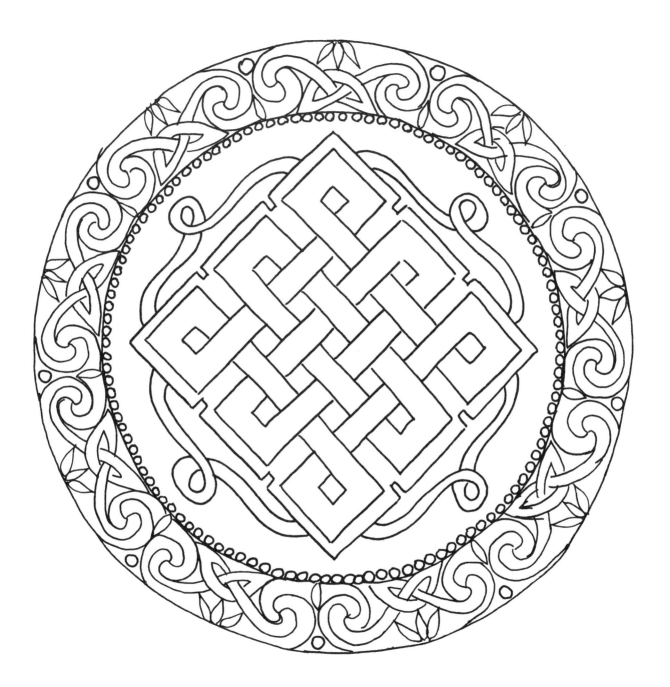

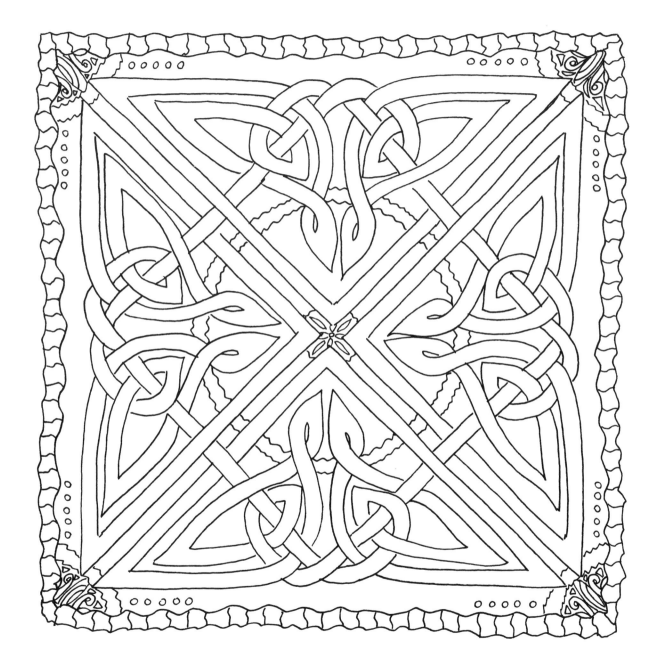

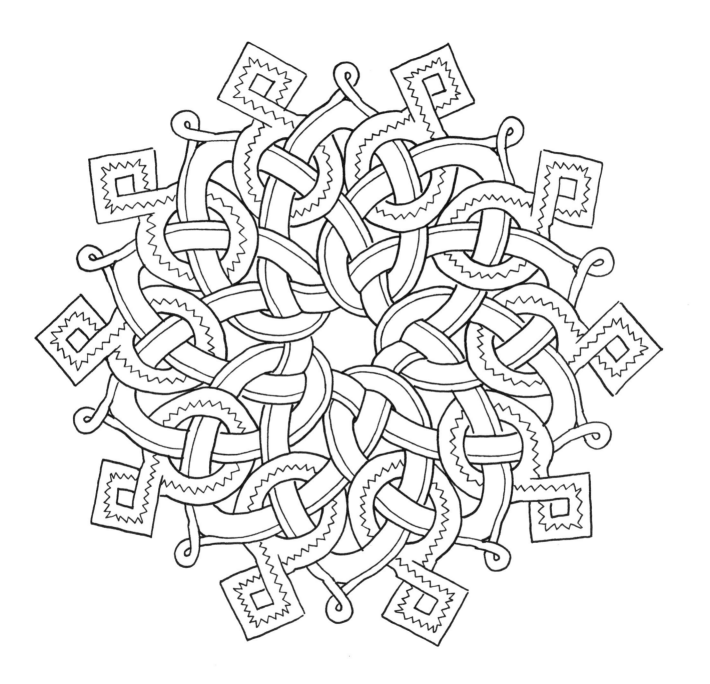

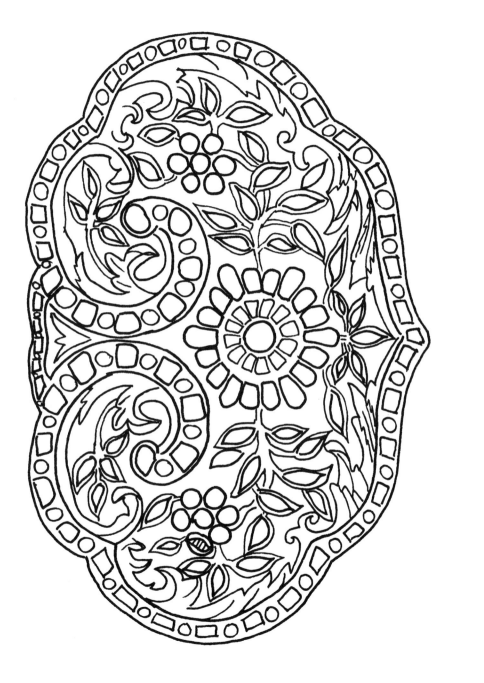

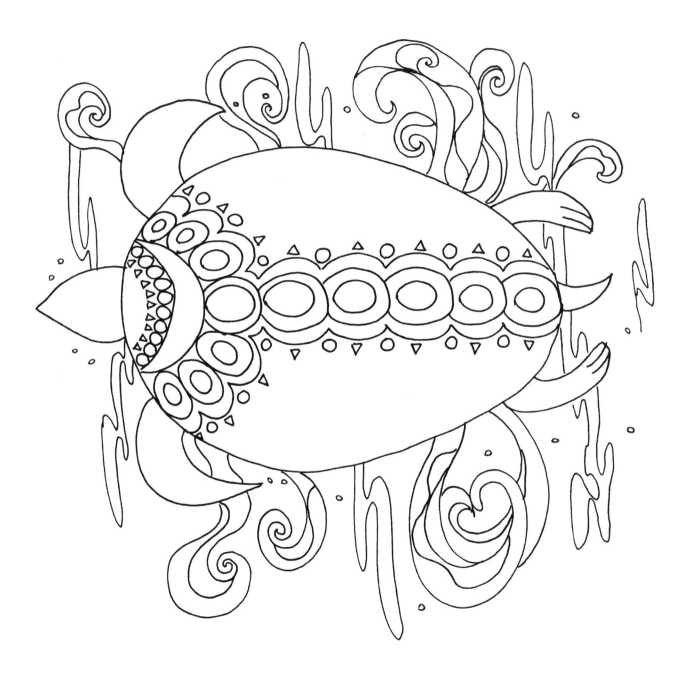

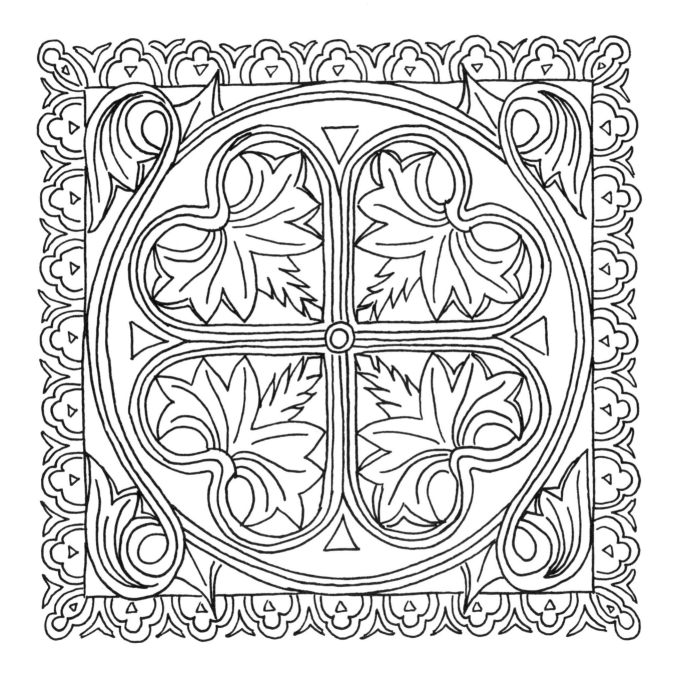

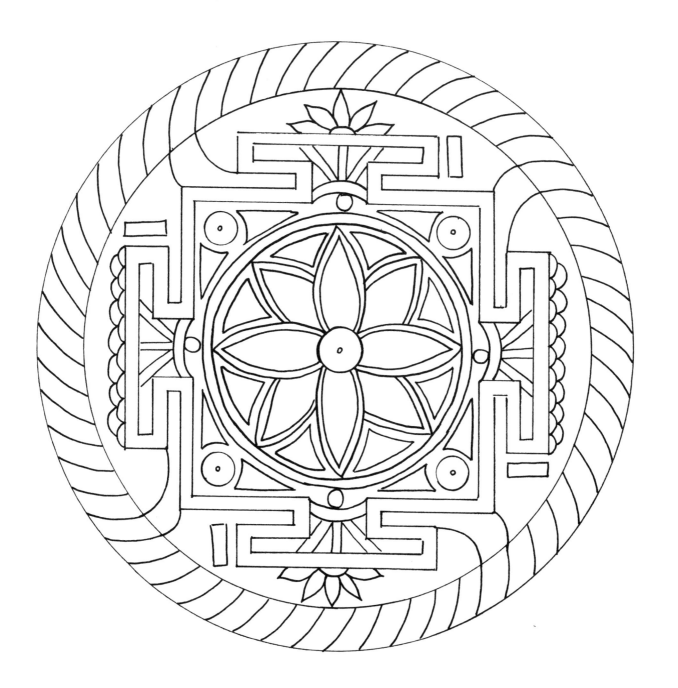

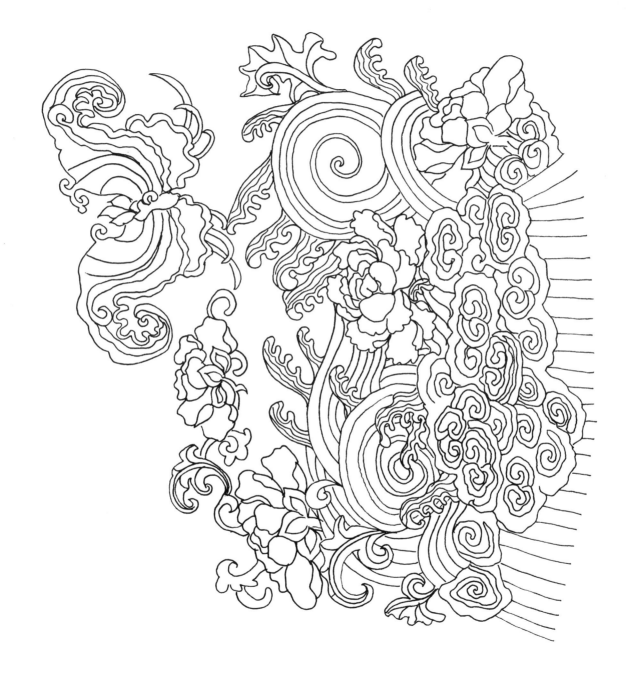

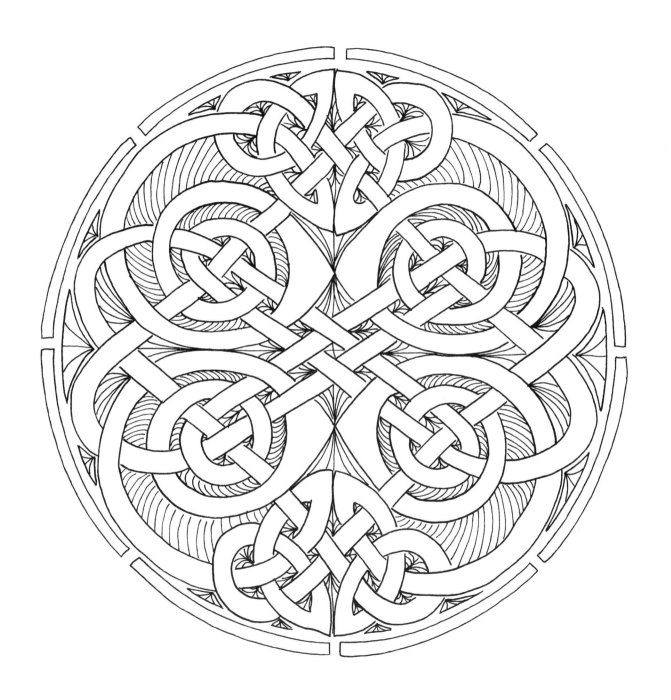

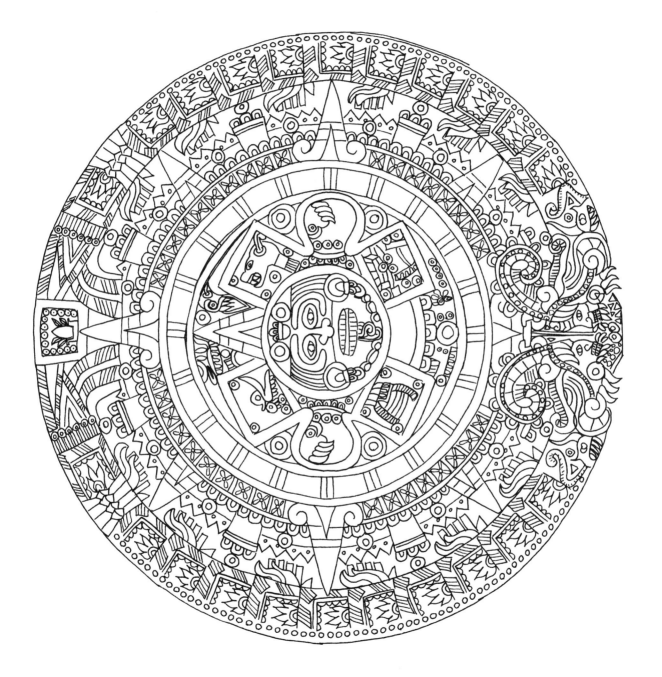

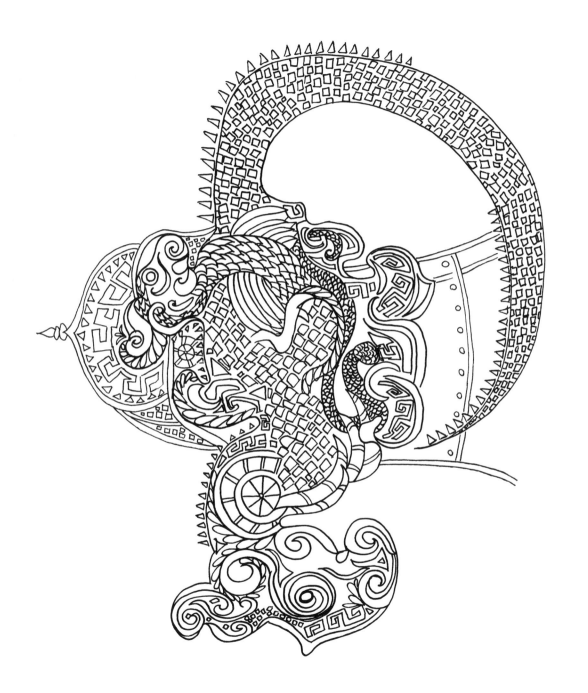

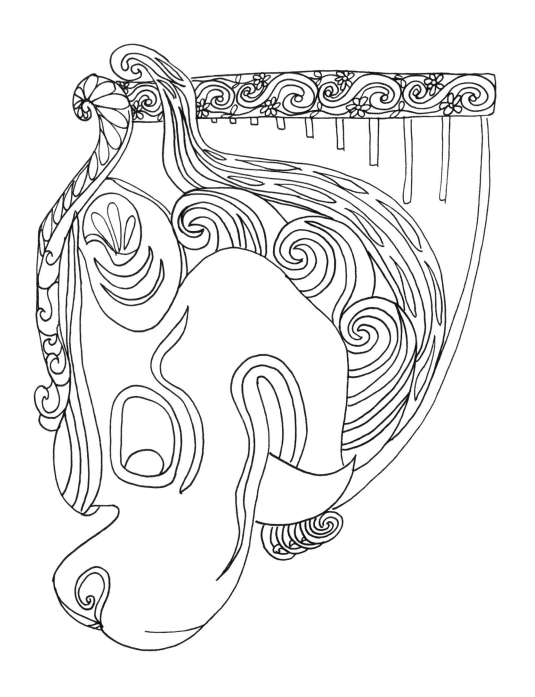

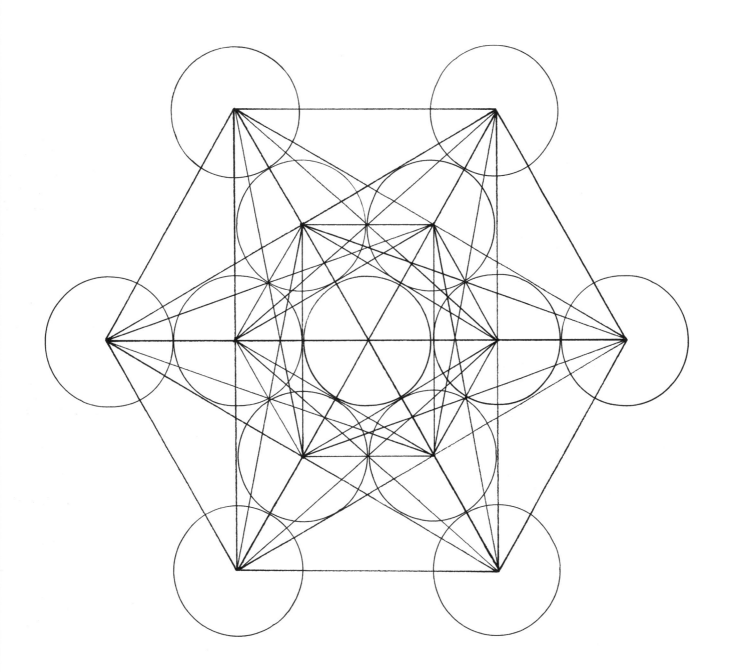

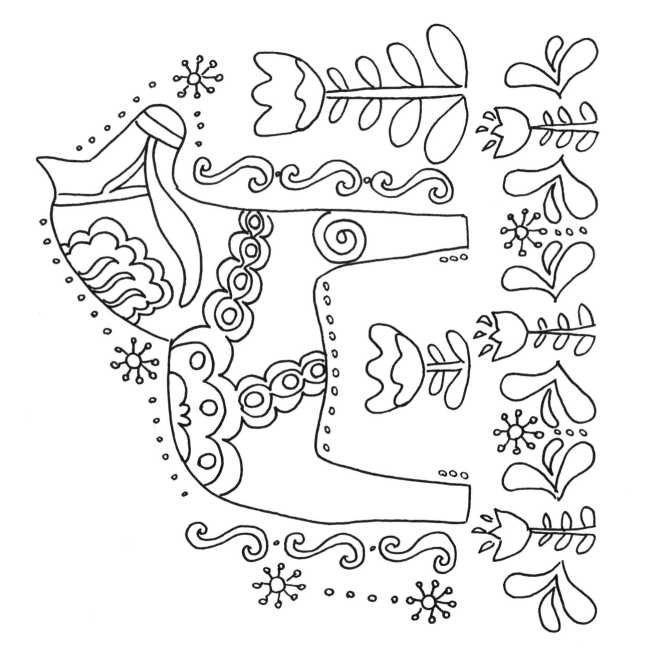

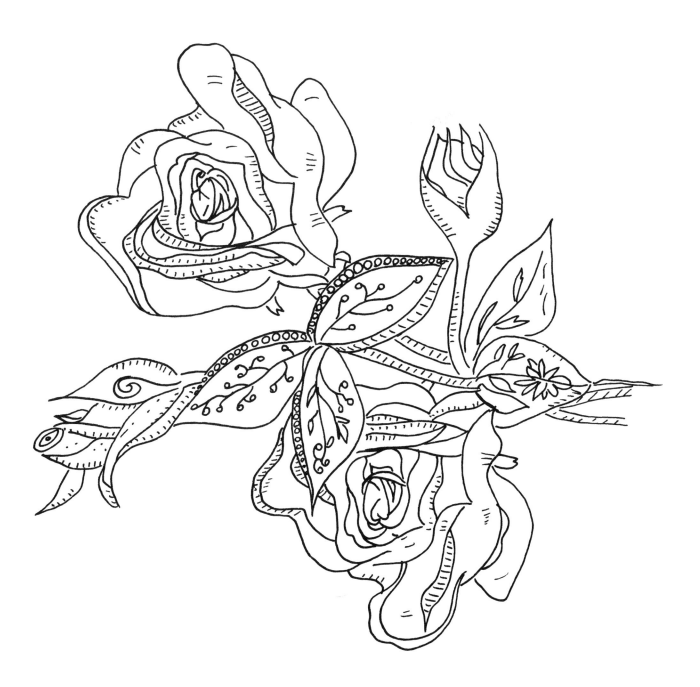

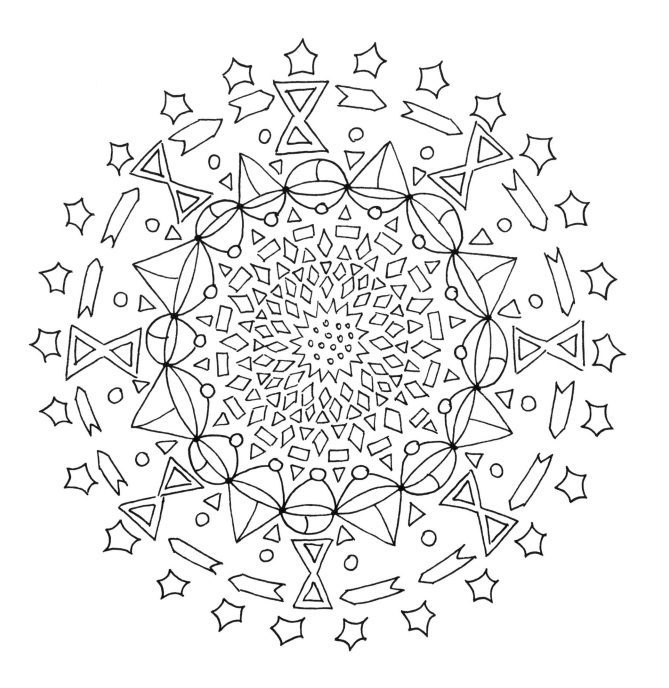

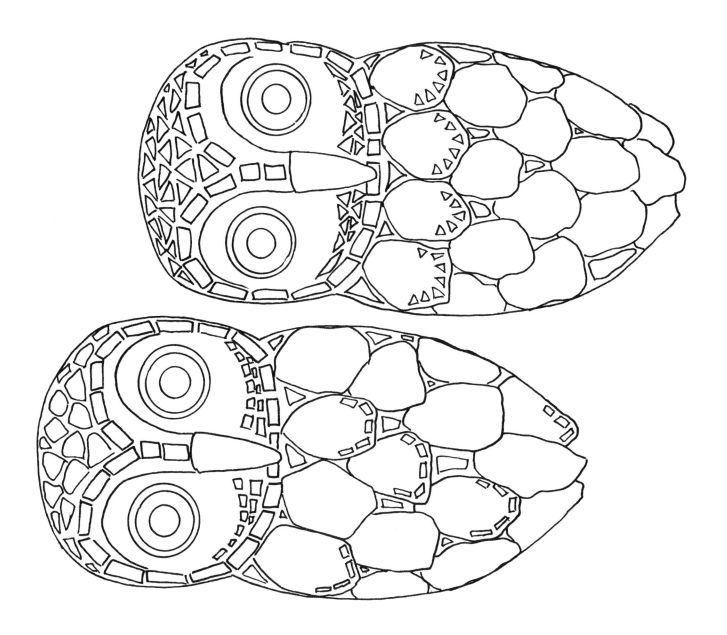

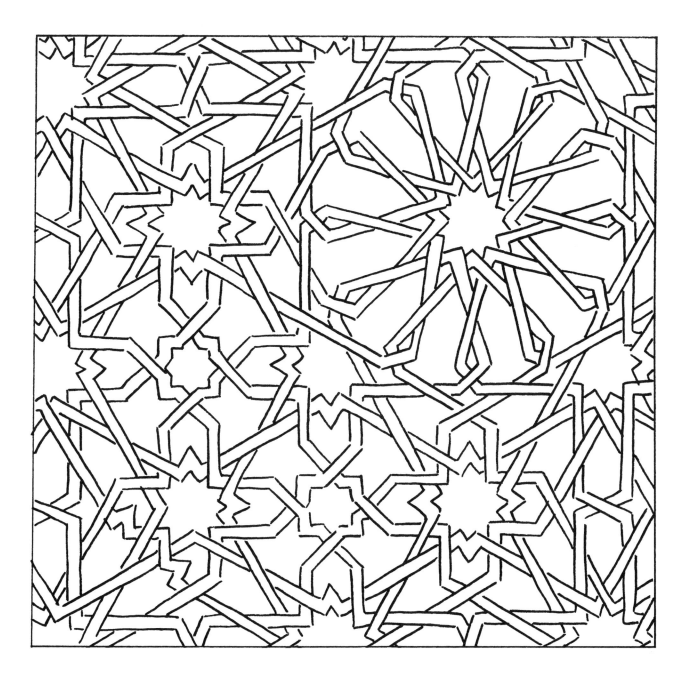

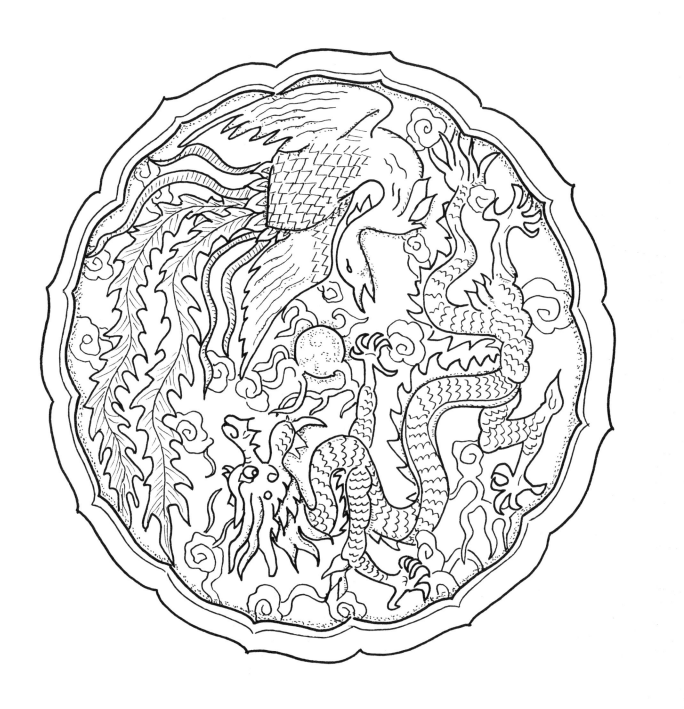

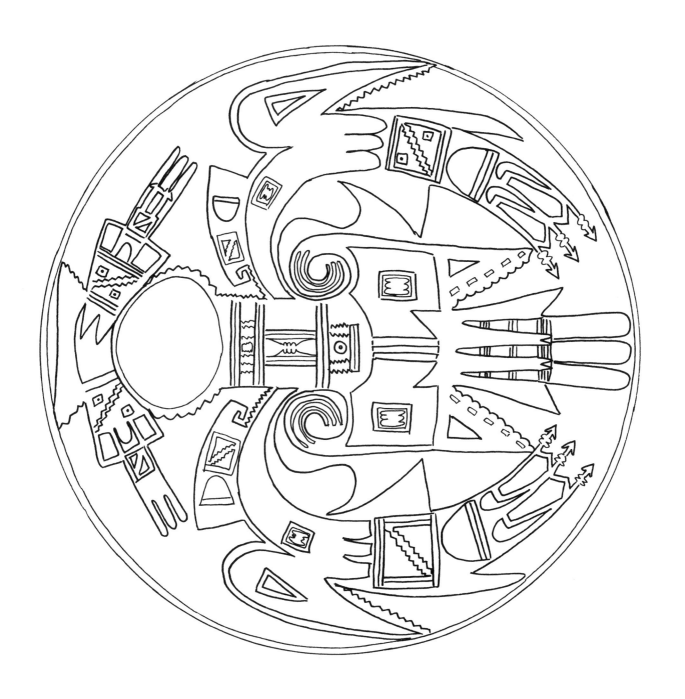

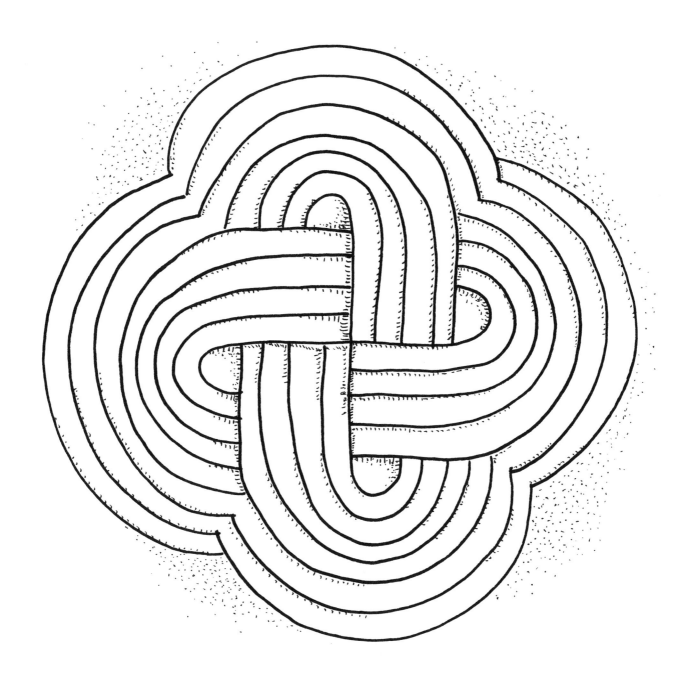

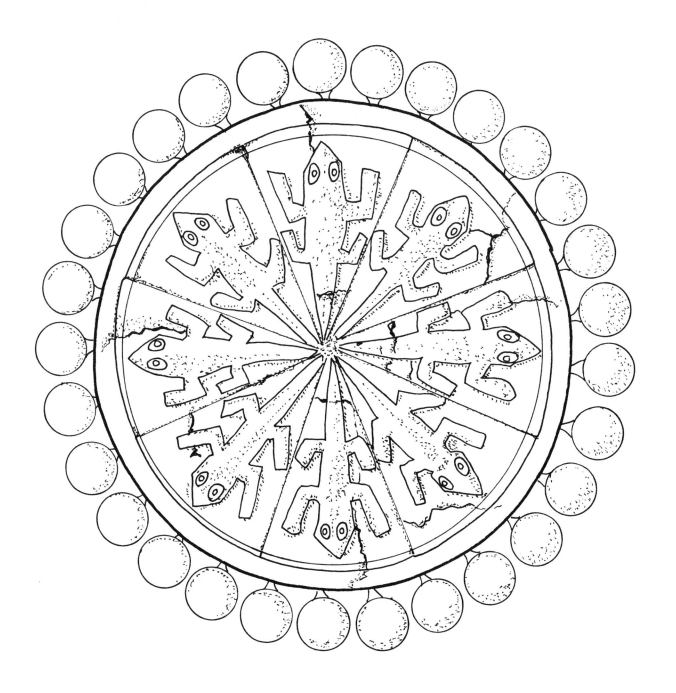

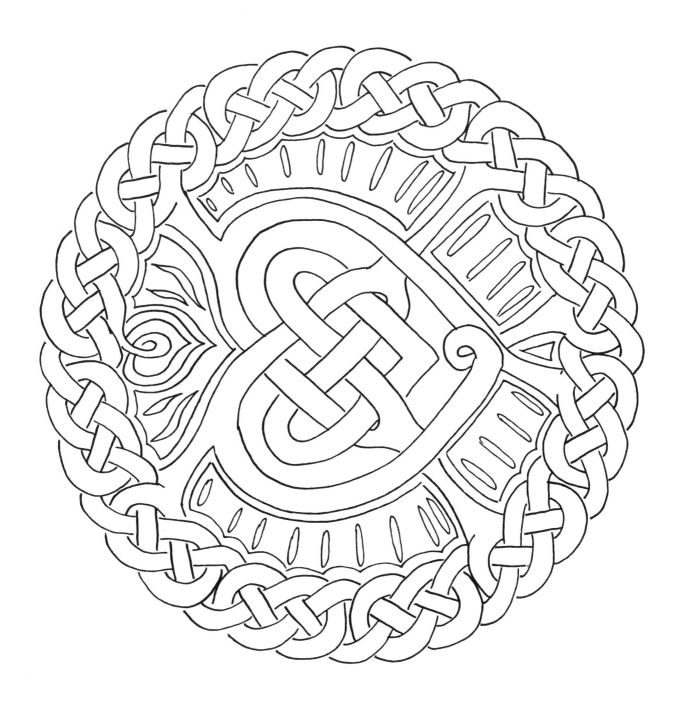

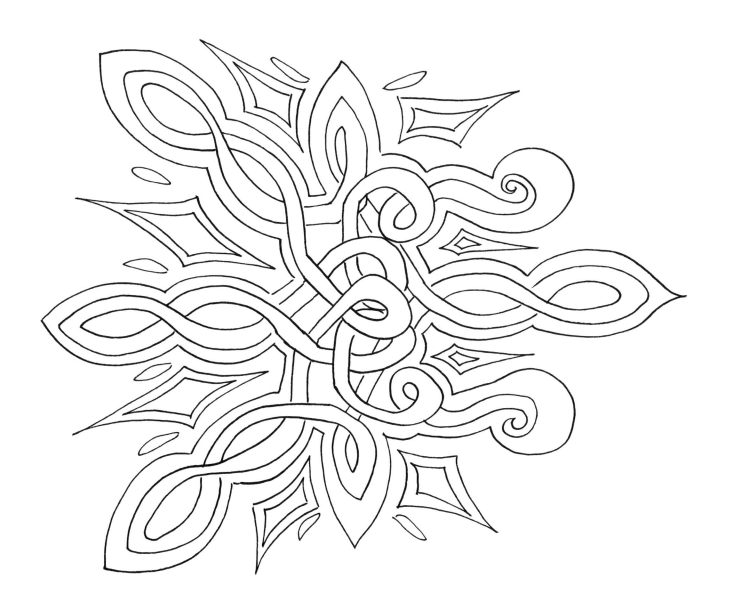

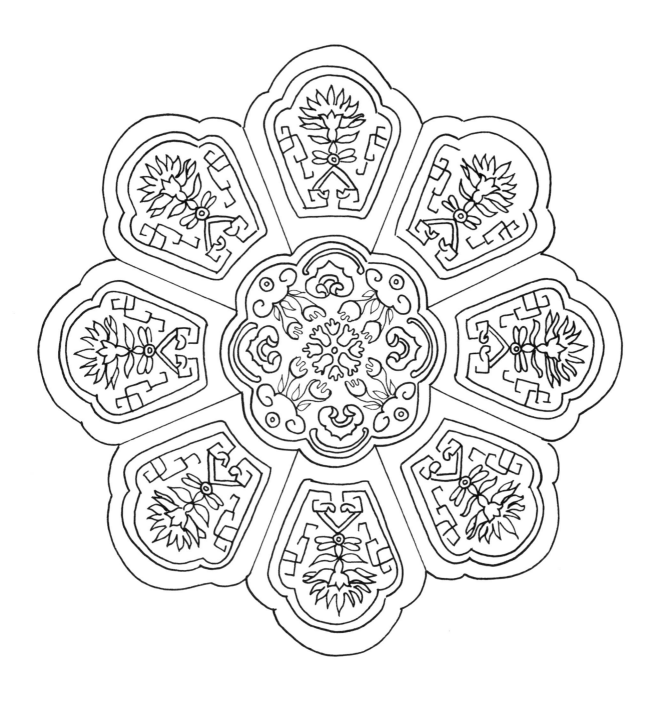

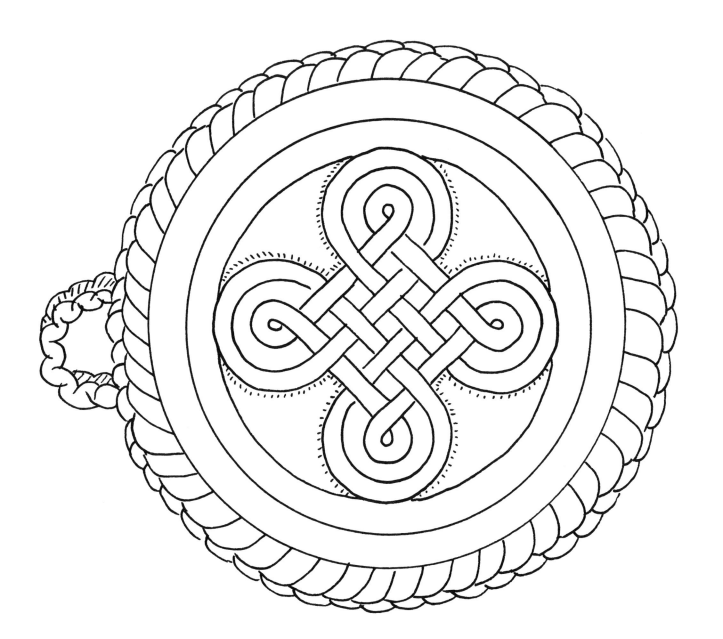

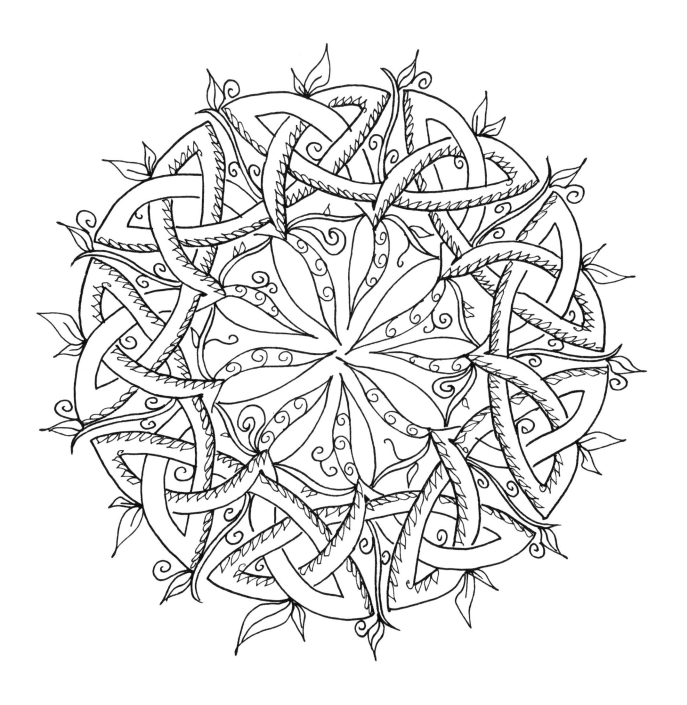

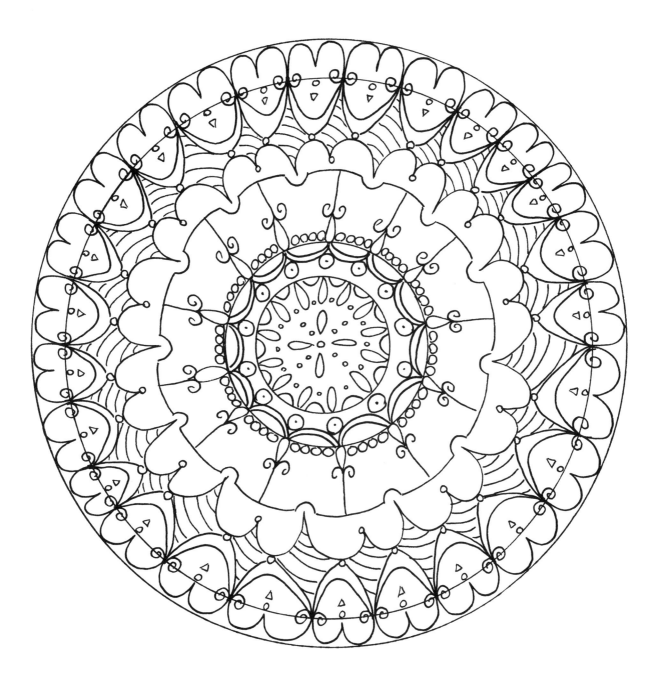

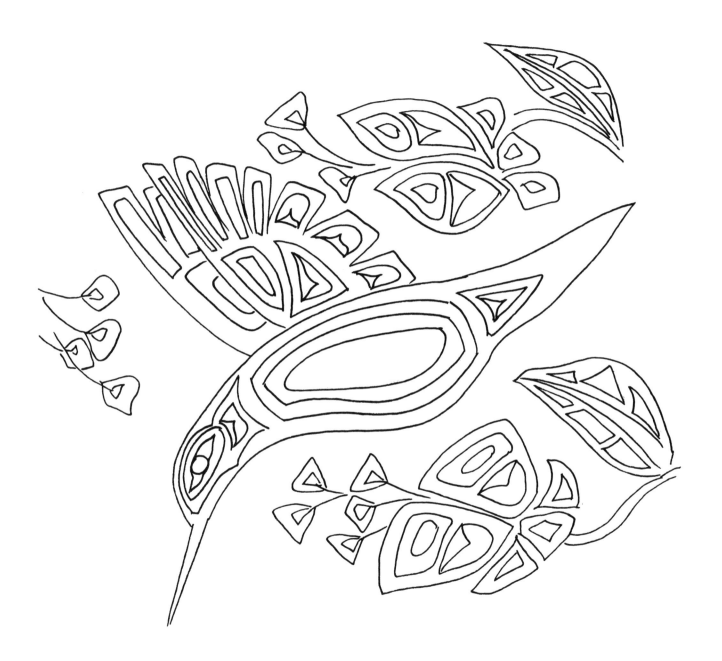

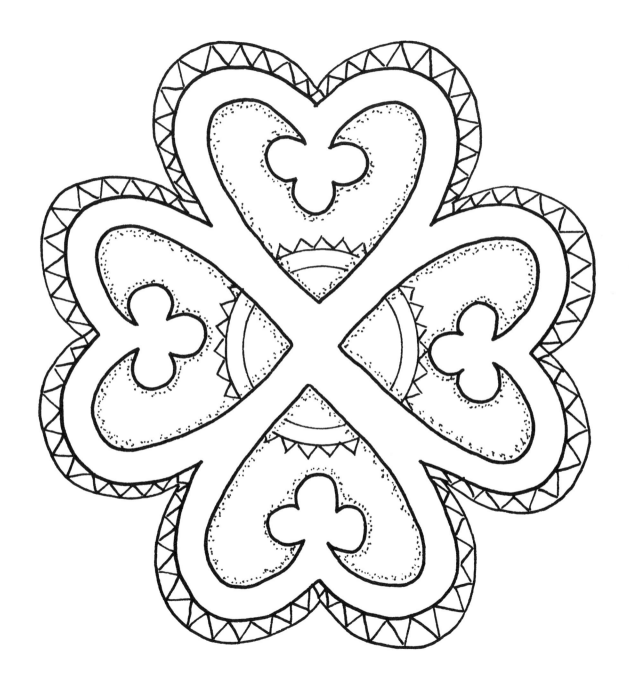

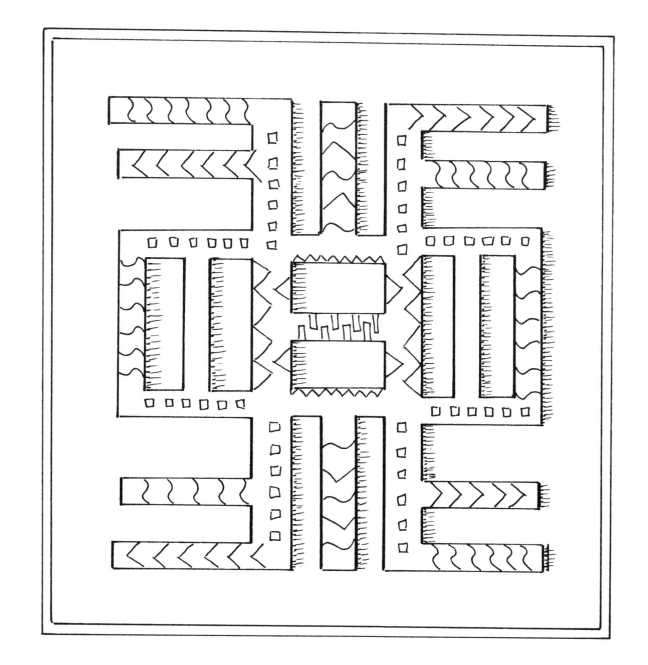

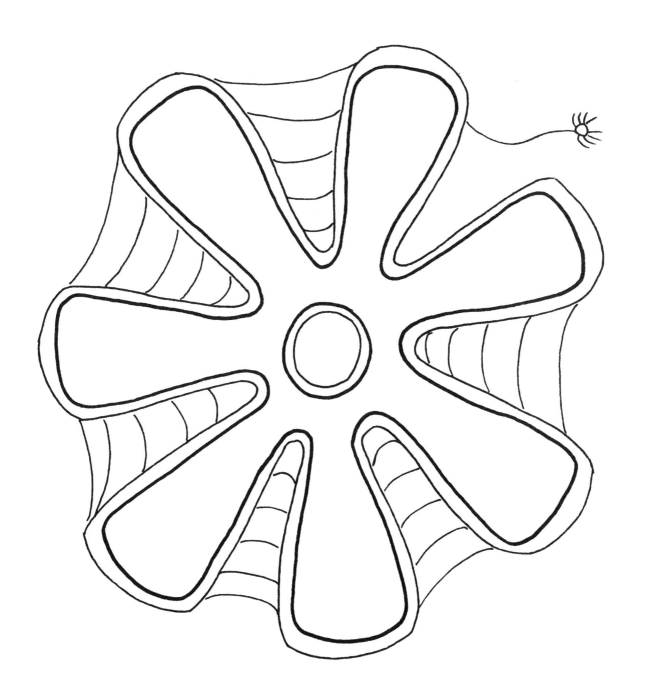

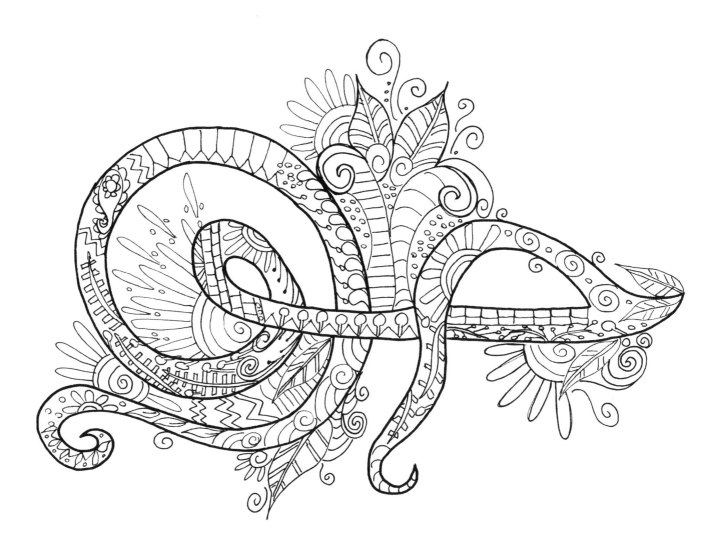

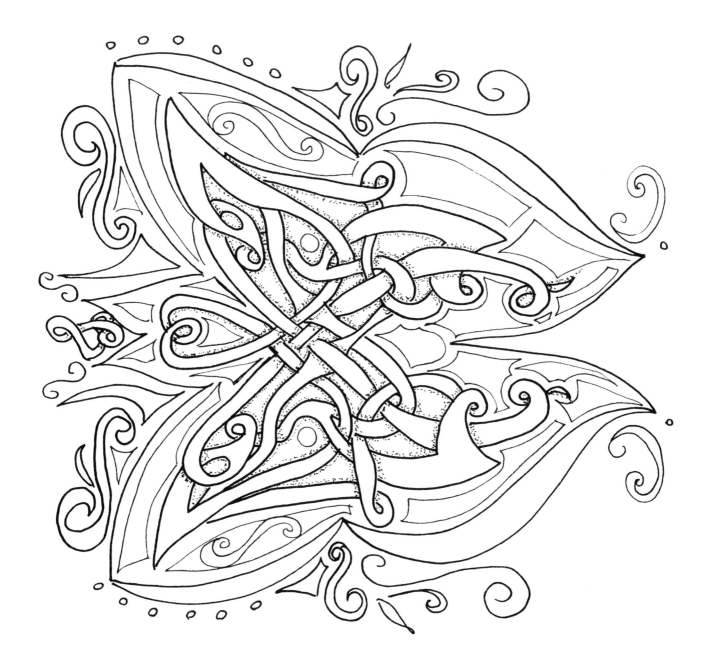

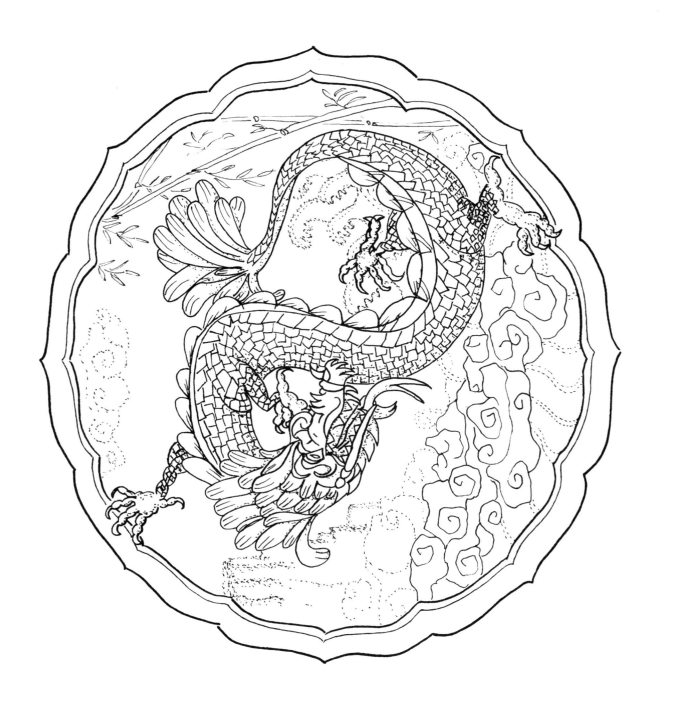

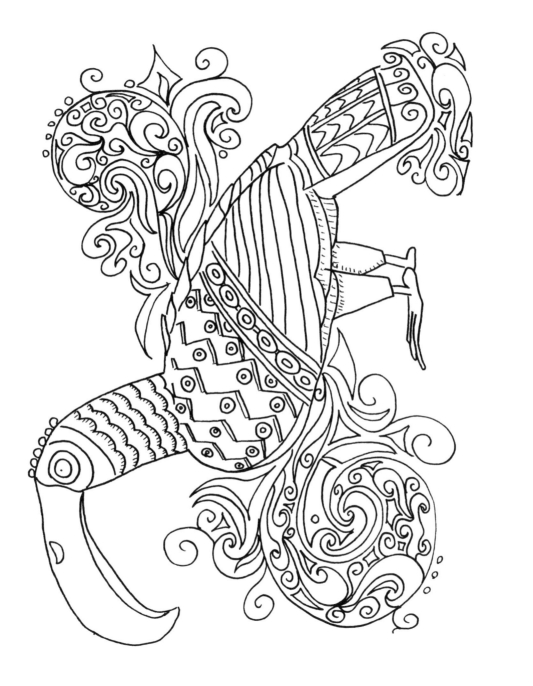

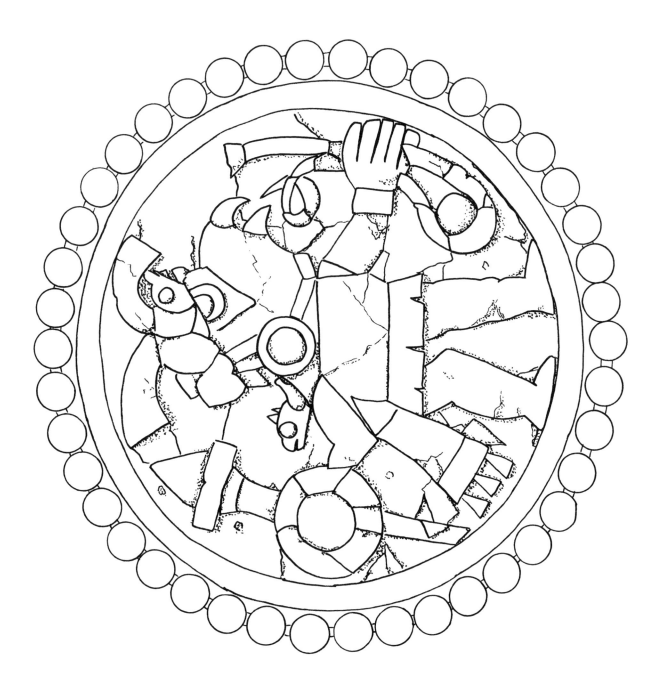

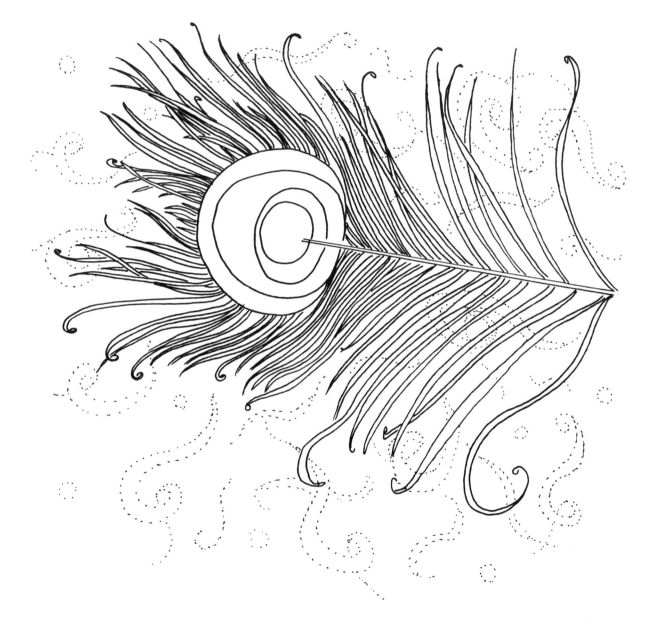

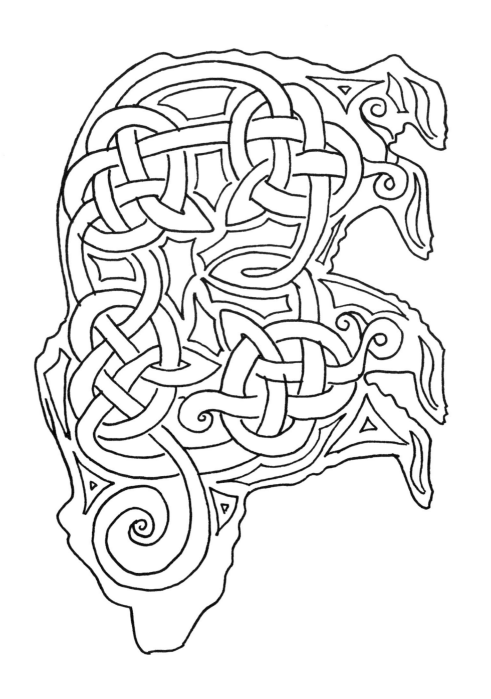

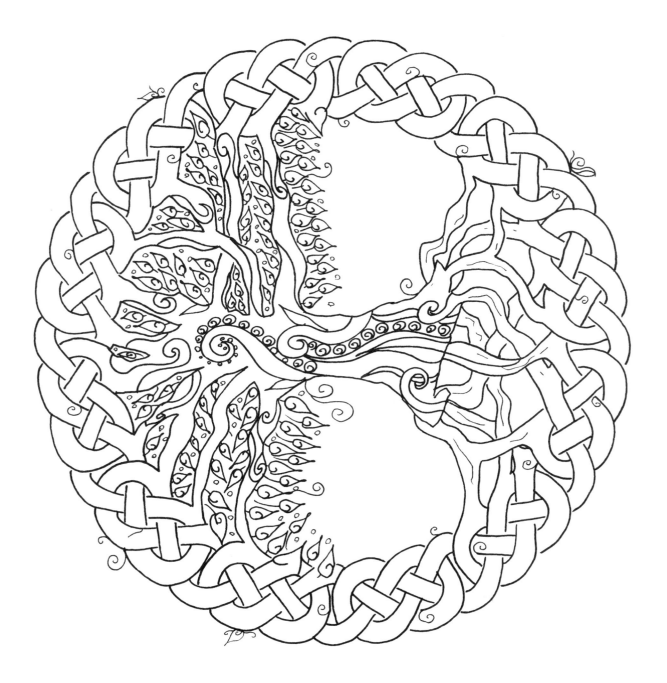

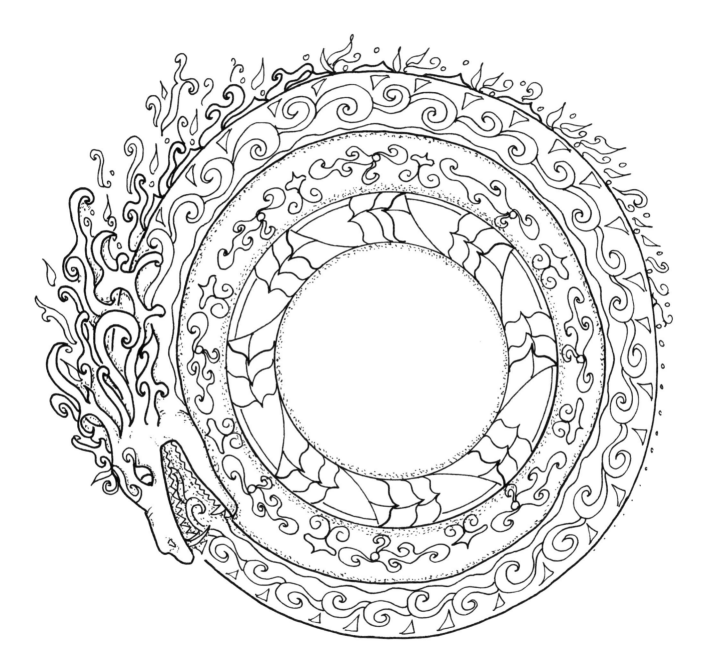

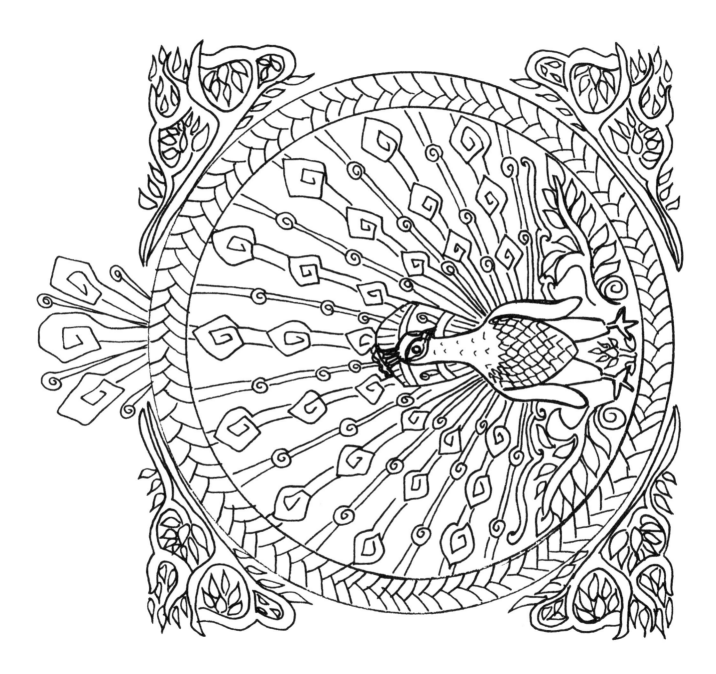

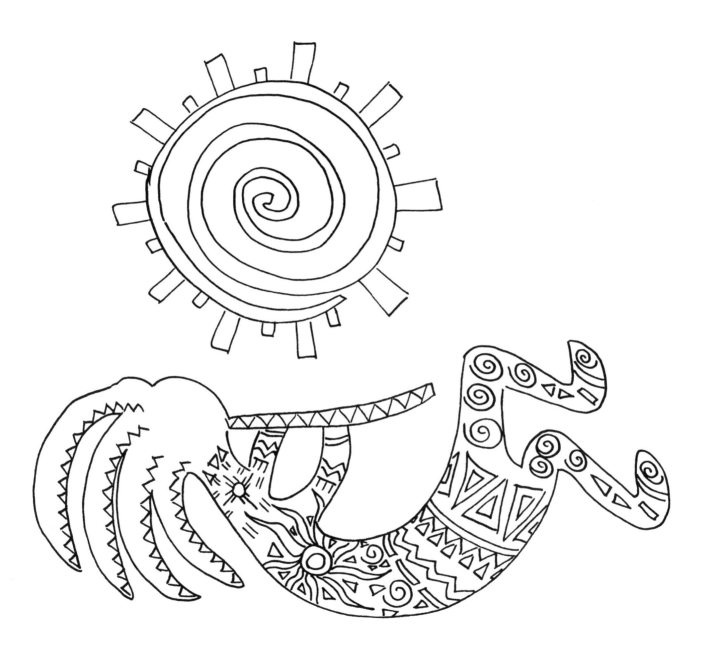

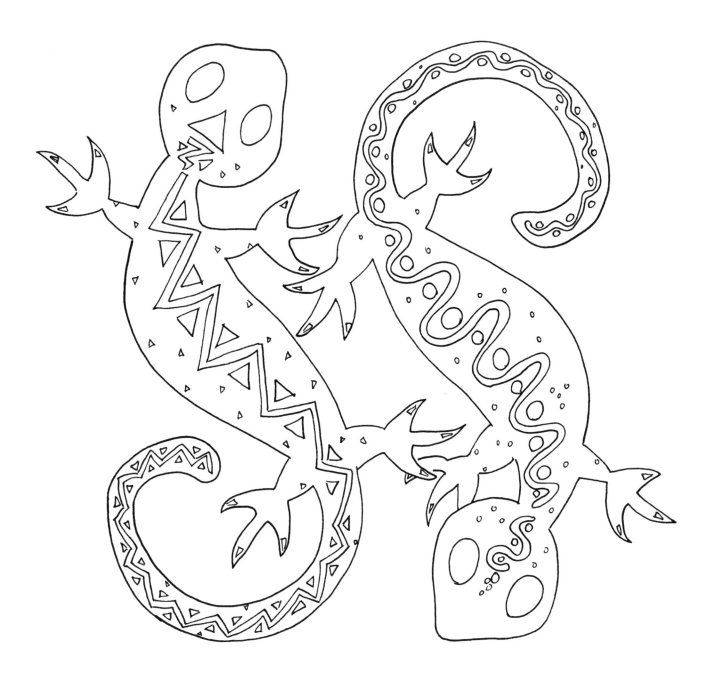

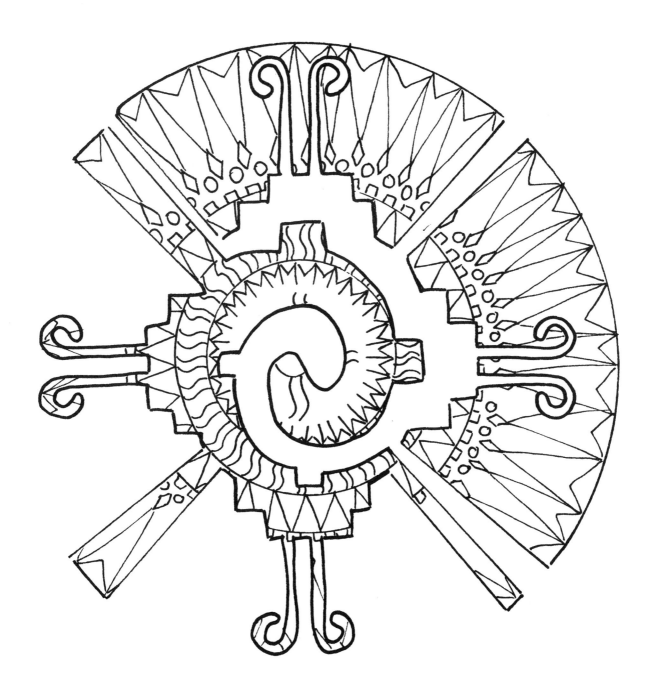

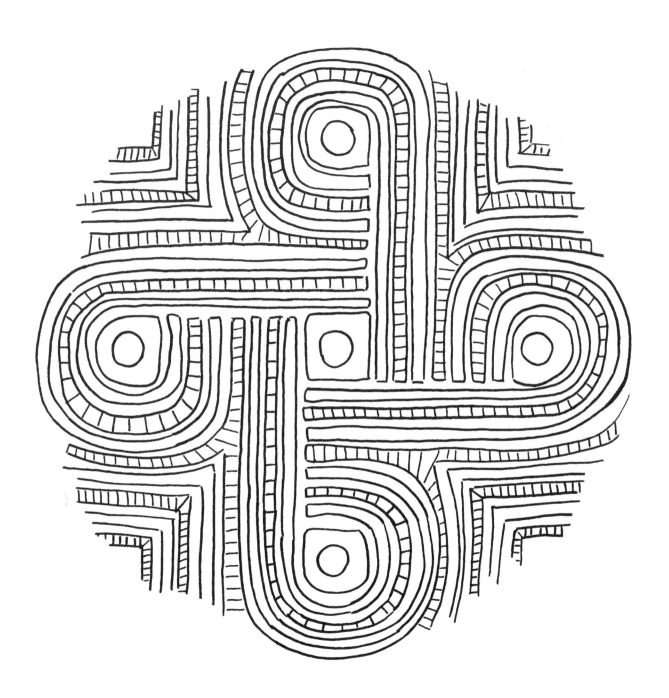

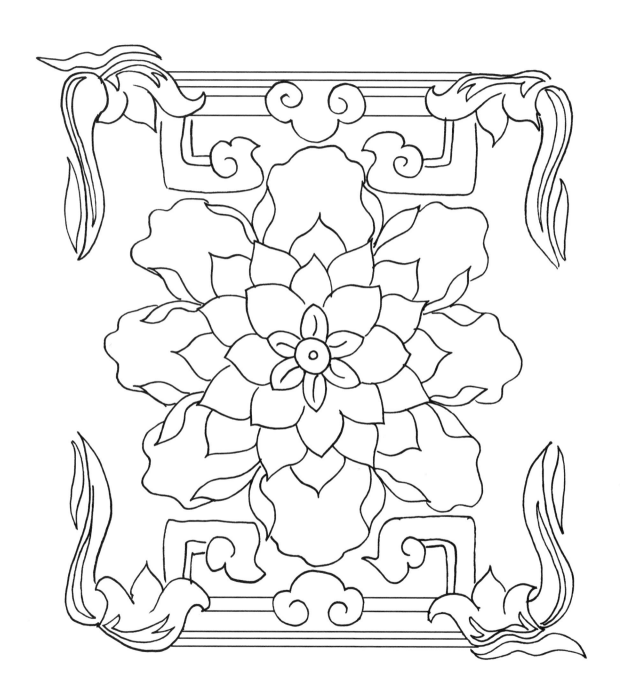

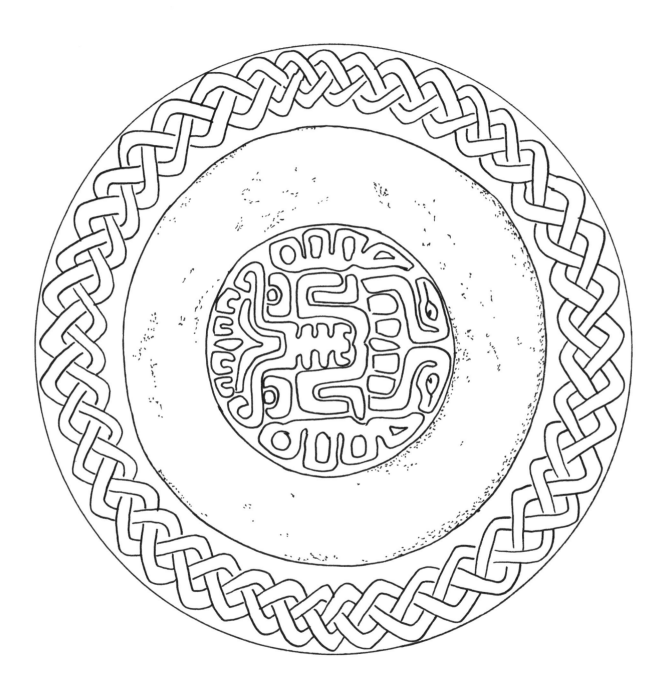

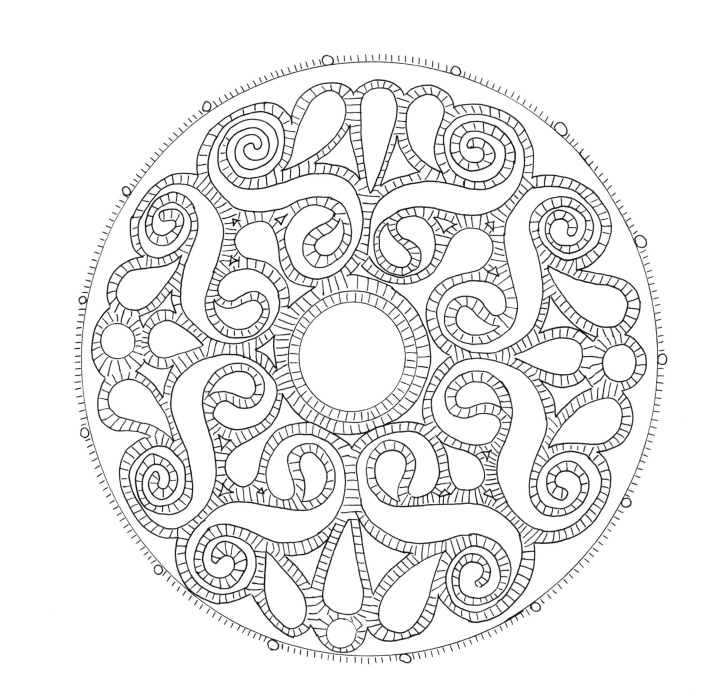

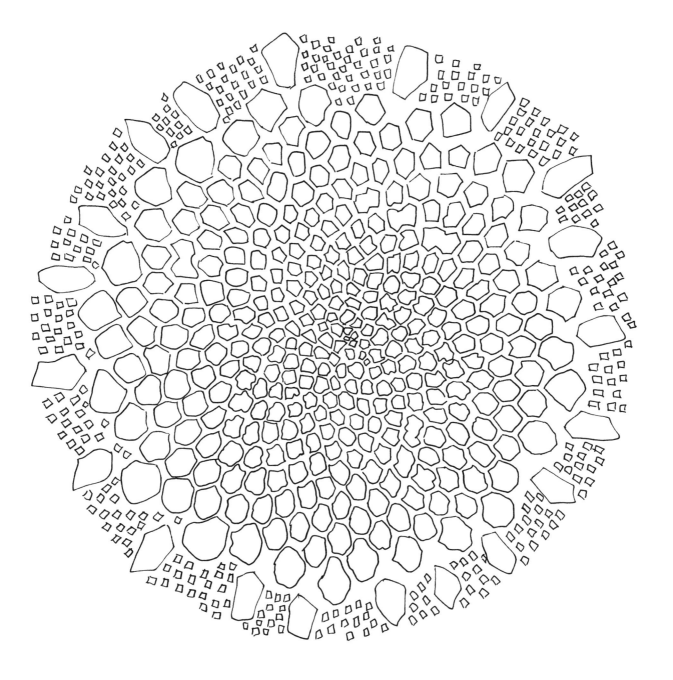

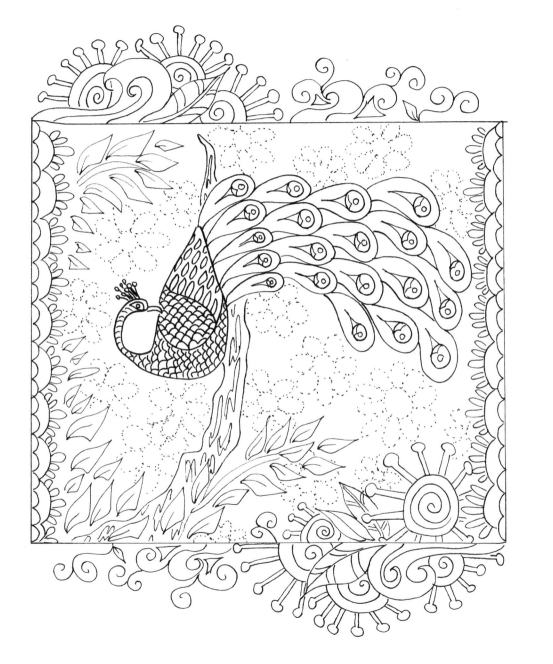

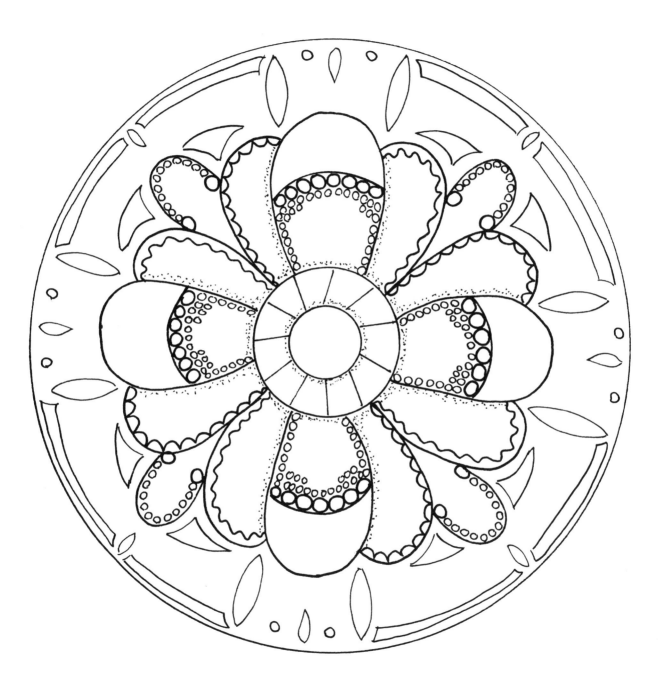

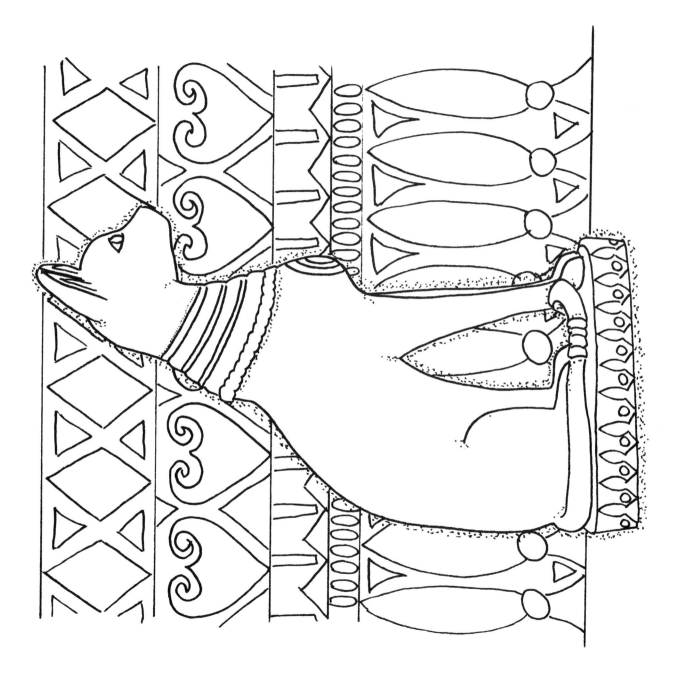

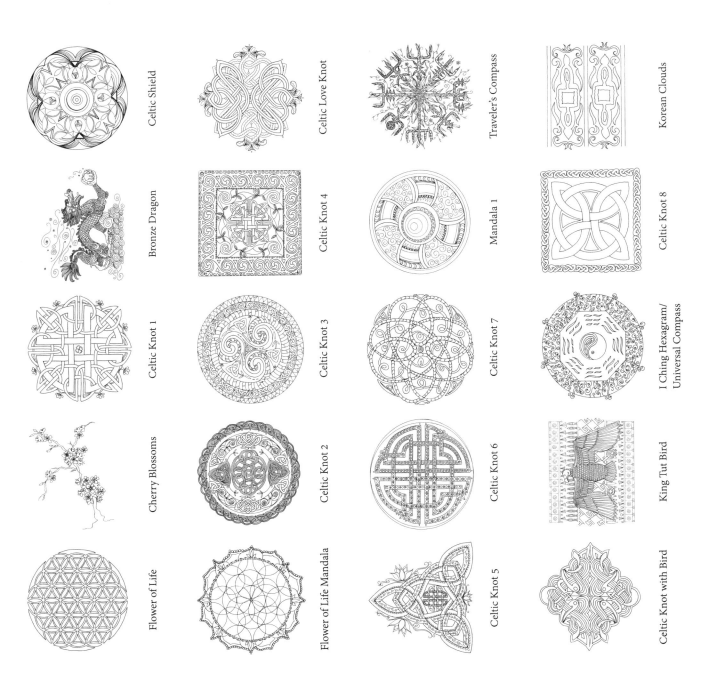

Celtic Shield

Celtic Love Knot

Traveler's Compass

Korean Clouds

Bronze Dragon

Celtic Knot 4

Mandala 1

Celtic Knot 8

Celtic Knot 1

Celtic Knot 3

Celtic Knot 7

I Ching Hexagram/
Universal Compass

Cherry Blossoms

Celtic Knot 2

Celtic Knot 6

King Tut Bird

Flower of Life

Flower of Life Mandala

Celtic Knot 5

Celtic Knot with Bird

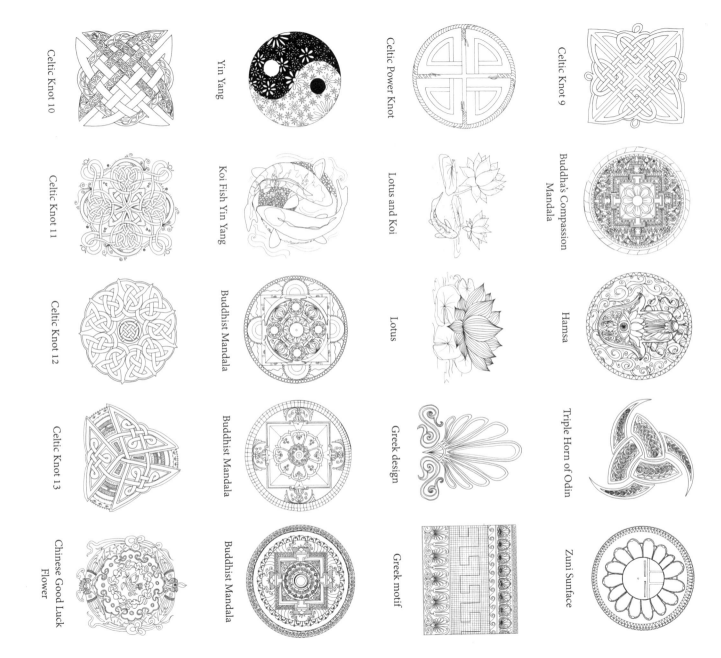

Celtic Knot 10

Yin Yang

Celtic Power Knot

Celtic Knot 9

Celtic Knot 11

Koi Fish Yin Yang

Lotus and Koi

Buddha's Compassion Mandala

Celtic Knot 12

Buddhist Mandala

Lotus

Hamsa

Celtic Knot 13

Buddhist Mandala

Greek design

Triple Horn of Odin

Chinese Good Luck Flower

Buddhist Mandala

Greek motif

Zuni Sunface

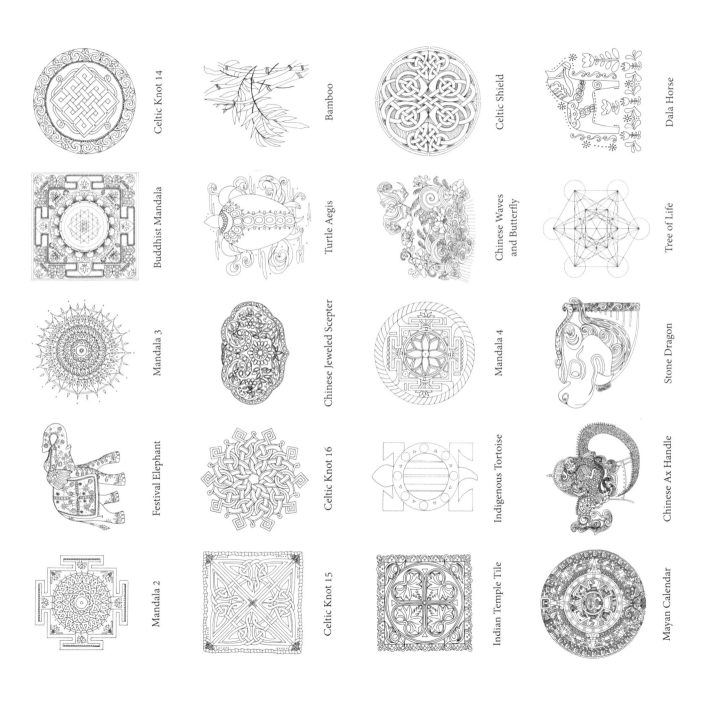

Celtic Knot 14

Bamboo

Celtic Shield

Dala Horse

Buddhist Mandala

Turtle Aegis

Chinese Waves and Butterfly

Tree of Life

Mandala 3

Chinese Jeweled Scepter

Mandala 4

Stone Dragon

Festival Elephant

Celtic Knot 16

Indigenous Tortoise

Chinese Ax Handle

Mandala 2

Celtic Knot 15

Indian Temple Tile

Mayan Calendar

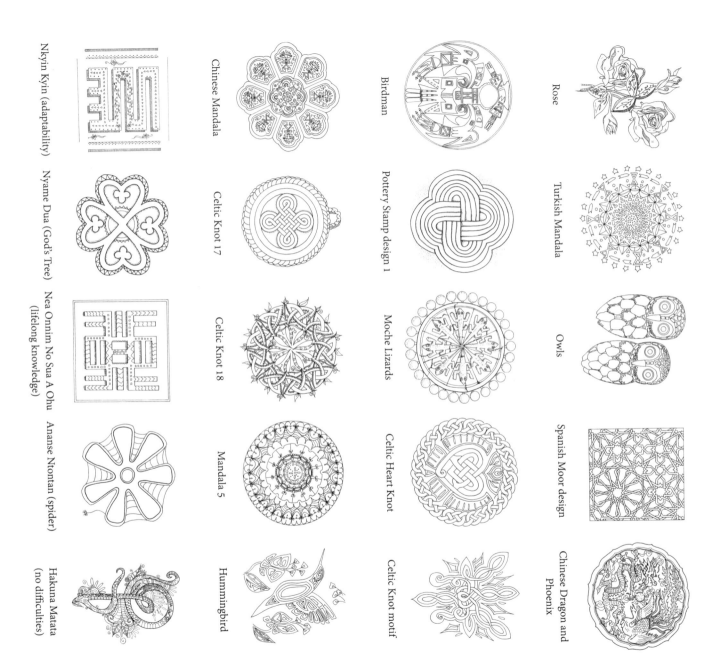

Nkyin Kyin (adaptability)

Chinese Mandala

Birdman

Rose

Nyame Dua (God's Tree)

Celtic Knot 17

Pottery Stamp design 1

Turkish Mandala

Nea Onnim No Sua A Ohu (lifelong knowledge)

Celtic Knot 18

Moche Lizards

Owls

Ananse Ntontan (spider)

Mandala 5

Celtic Heart Knot

Spanish Moor design

Hakuna Matata (no difficulties)

Hummingbird

Celtic Knot motif

Chinese Dragon and Phoenix

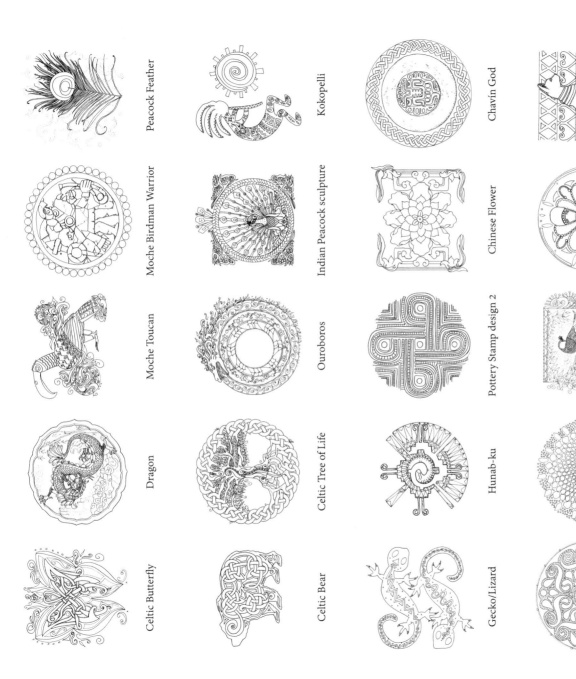

Peacock Feather

Kokopelli

Chavin God

Egyptian Cat

Moche Birdman Warrior

Indian Peacock sculpture

Chinese Flower

Mandala 6

Moche Toucan

Ouroboros

Pottery Stamp design 2

Peacock at Rest

Dragon

Celtic Tree of Life

Hunab-ku

Sunflower Center

Celtic Butterfly

Celtic Bear

Gecko/Lizard

Ancient Gold Jewelry